IMAGES
of America

HANCOCK COUNTY

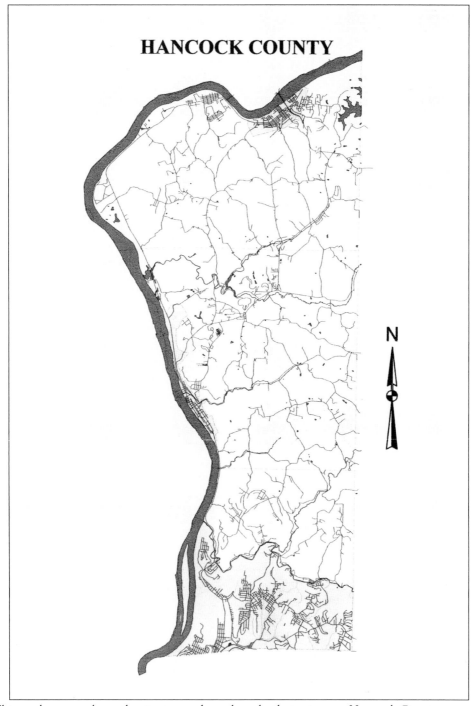

HANCOCK COUNTY

This modern map shows the streets, roads, and creeks that crisscross Hancock County.

ON THE COVER: The Popular Evans News All Stars played a team from Burgettstown, Pennsylvania, on August 12, 1939, at 2:30 p.m. at Eden Park to celebrate the centennial of New Cumberland. The full image appears on page 4. (Courtesy of Joyce Frain, *Hancock County Courier*.)

IMAGES
of America

HANCOCK COUNTY

George B. Hines III and Lou Martin

ARCADIA
PUBLISHING

Published by Arcadia Publishing
Charleston, South Carolina

Printed in the United States of America

Library of Congress Catalog Card Number: 2006927170

For all general information contact Arcadia Publishing at:
Telephone 843-853-2070
Fax 843-853-0044
E-mail sales@arcadiapublishing.com
For customer service and orders:
Toll-Free 1-888-313-2665

Visit us on the Internet at www.arcadiapublishing.com

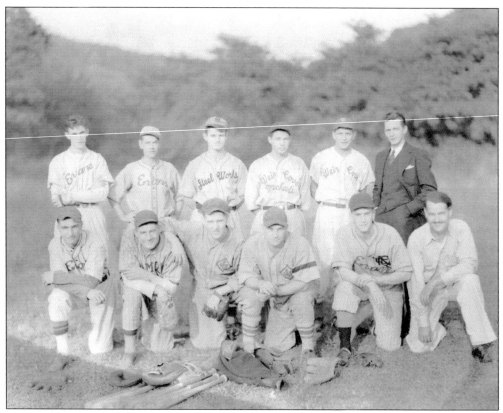

The Popular Evans News All Stars includes, from left to right, (first row) John Kuzio, Lefty Brigodie, Tubby Nolan, Lenny Lawson, Chuck Belt, and Jack Evans; (second row) Nate Clark, manager Press Evans, Benny Costello, Dutch Dugan, Wade Kolosky, and Cliff Stout. Scorer Evans is not pictured. (Courtesy of Joyce Frain, *Hancock County Courier*.)

CONTENTS

ACKNOWLEDGMENTS

The authors would like to thank the many people and businesses that helped make this book possible by contributing images, information, and other assistance, including Sean Adkins, George Allison, Bill and Jeanne Barrett, Shari Byers-Pepper and the Weirton Historic Landmarks Commission, Doris Cameron, Brian and Jack Carson, Mary and Donald Chaney, Catherine Cowl Watson and Pat Cowl Law, Rick Cronin and National Church Supply, Tamara Cronin and Chuck Saus of Mountaineer Race Track and Gaming Resort, Rick Davis, Victor Greco, Chester Grossi, the Hancock County Commissioners, Linda Hawkins, Mary Ann Johnston, Dennis Jones, Pamela Makricosta, Alice Mitchell, Bob McNeil, Nessly Chapel, Newbrough Photos, Mary Porter, Doris Swain, Top Dog Restaurant, Sharon Harris Ulbright, Robert Wells, and Dr. Mike West.

A special thanks to Joyce Frain of the *Hancock County Courier*; Pete Arner, Doug Arner, and Arner Funeral Chapel; Ken Morris and the City of Chester; the City of New Cumberland; Homer Laughlin China Company (especially Ann Culler, Barb Watson, and Pat Shreve); Edmund DiBacco and the People's Choice Café; Caroline Castelli Herron and Weir-Cove Moving and Storage; the Hancock County Historical Museum; Milli Hines; and Krista Martin.

We are very thankful to the many, many people who have helped us, and we apologize if we left anyone out.

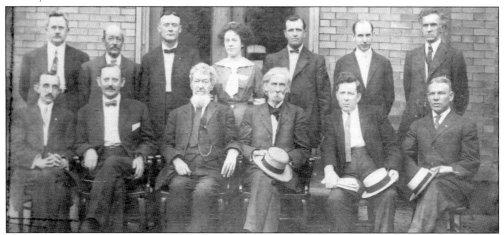

Posing in front of the Hancock County Courthouse in 1912 are, from left to right, (first row) Thomas M. Cochran, circuit clerk; E. A. Hart, attorney; John R. Donehoo, attorney; O. S. Marshall, attorney; James A. McKenzie, attorney; and Armour S. Cooper, county clerk; (second row) Frank L. Bradley, lawyer; Ed Grafton, county engineer; George L. Bambrick, prosecuting attorney; Pearl Cline, stenographer, county clerk's office; Robert R. Hobbs, sheriff; R. M. Brown, lawyer; and John A. Campbell, judge. (Courtesy of the New Cumberland Municipal Collection.)

INTRODUCTION

Both authors grew up in Hancock County and have always had an interest in its history. After George Hines started working for the City of New Cumberland, he began collecting old photographs of the town and displaying them at the Municipal Building. Old photographs have the ability to intrigue people by showing what has changed and what has stayed the same, but they can also give a community a deeper sense of its past. Hopefully this collection of images will also shed light on how each community fits into the larger history of the county and provide a glimpse into the variety of life experiences in Hancock County over generations.

Hancock County is presently going through a period of dramatic change. Between 1960 and 2000, Hancock County lost about 7,000 residents. In 1960, some 61 percent of the county's labor force worked in manufacturing, but by 2000, that had dropped to about 25 percent. While employment at Mountaineer Race Track and Gaming Resort increased dramatically in the 1990s, and the resort now employs over 1,700, that increase did not make up for the roughly 4,700 jobs lost in manufacturing during those years. Young graduates and sometimes even whole families moved to other parts of the country in search of opportunities. As the county transitions from a manufacturing economy to one based on tourism and the service sector, now may be the perfect opportunity to reflect on previous turning points in the county's history.

Hancock County is the smallest and northernmost county in West Virginia. The Ohio River forms its northern and western border, while Pennsylvania forms its eastern border. The Virginia legislature carved it out of the northern half of Brooke County in 1848 in response to petitions from residents of the northern part of the county who complained about the distance they had to travel to the former county seat of Wellsburg. The county takes its name from the revered signer of the Declaration of Independence John Hancock.

The county experienced two major shifts earlier in its history. The first change occurred at the beginning of the 19th century, as early settlers made the transition from frontiersmen to commercial farmers, spending less time hunting and trapping and far more time clearing land, milling wheat, cultivating orchards, and improving the breeds of their livestock. In 1824, Joseph Doddridge, an early settler, noted that the area was no longer the frontier of his childhood and that he was now "surrounded by the busy hum of men, and the splendor, arts, refinements and comforts of civilized life." With an economy based on agriculture and being a relatively small county, Hancock grew very slowly. In 1850, just over 4,000 people called Hancock County home, only 130 of whom worked in manufacturing, mostly in New Cumberland's brickyards. Hugh Pugh was probably typical of the county's farmers in 1850. He owned 200 acres of cleared land and 100 acres of "unimproved" land. He tended 106 sheep and 10 hogs, grew 450 bushels of wheat and 300 bushels of corn, and produced 200 pounds of butter. Over the next four decades, the county's population increased by about 2,000, totaling 6,414 in 1890.

Commercial farmers in the county focused on wheat cultivation in the early decades of the 19th century. A number of grain mills in the county produced high-quality flour, much of it to be shipped down the Ohio River to New Orleans for export. As the price of flour dropped rapidly

in the 1820s and 1830s, farmers in the county shifted their focus from wheat to wool and apples. Scottish and Irish immigrants brought knowledge of raising sheep to the upper Ohio Valley, and they believed that the rolling hills and native clover made the area perfect for raising sheep. By 1890, sheep outnumbered residents two to one. Apple orchards also presented an alternative to wheat. In particular, local orchards produced the Willow Twig apple, which has become somewhat rare in recent decades. In 1890, Hancock County orchards produced more than 100,000 bushels of apples.

Beginning around 1900, the arrival of new industries marked the second major transition. Bridges built across the Ohio River from East Liverpool facilitated the expansion of the pottery industry from the Ohio side into the new towns of Chester and Newell. The Chester Bridge opened on New Year's Eve, 1896, and the Newell Bridge opened on July 4, 1905. Chester and Newell became home to several potteries, including the Knowles Pottery; Taylor, Smith, and Taylor (or TS&T); Harker; and Homer Laughlin, which was the largest pottery in the world at the time of its construction and at its peak employed some 3,000 workers.

In 1909, Ernest Weir located a new steel mill near Hollidays Cove in what came to be the town of Weirton. Weir's company, then named Phillips Sheet and Tin Plate after J. R. Phillips, his deceased business partner, produced tin plate to serve the exploding market for canned food. When production began, the company purchased bar steel from basic steel producers and rolled it into sheets in Weirton's rolling mills. In 1918, the small steel firm incorporated and changed its name to Weirton Steel. In 1919, the company built a 600-ton blast furnace and, the following year, added seven 100-ton open-hearth furnaces. The addition of these departments enabled the company to produce its own steel and created thousands of new jobs that attracted African Americans from the South and immigrants from as far away as Italy and Greece. At its peak, Weirton Steel employed 13,000.

In short order, industrialization transformed the county. In 1890, a mere 250 county residents worked in manufacturing, but by 1940, that number had grown to over 14,000, and the county's population more than quadrupled to over 30,000. The steady paychecks of the industrial workers helped provide for families and build communities. Home ownership rates climbed steadily from about 50 percent in 1940 to over 70 percent by 1980. Their children were able to stay in school longer. In 1950, the average adult in the county had only completed 8 years of school, but by 1970, that figure had increased to an average of 11.3 years. Residents built and rebuilt churches to serve the ever-diversifying population and formed a myriad of civic organizations and fraternal organizations. They celebrated holidays with numerous parades and spent their leisure time at the county's parks, movie theaters, and racetrack. This era of prosperity created enduring and proud communities. Despite recent periods of hardship, for most of its history, the county has enjoyed high employment, high rates of home ownership, and low crime rates for generations, making it an ideal place in many ways to raise a family.

One

FRONTIERSMEN AND FARMERS

Several modern native peoples lived in and traveled through the Ohio River Valley by the mid-18th century—including the Shawnee, Iroquois, and Mingo—who have a rich and important history of their own. Most famously, Chief Logan of the Mingo may have lived in Hancock County. Local settler Daniel Greathouse, who built a small fort near present-day Newell in 1770, may have been responsible for the massacre of Logan's family, which led to Logan's historic and eloquent speech that concluded, "Who is there to mourn for Logan? Not one."

The signing of the Treaty of Greenville in 1795 marked the end of the Native American wars in the Ohio Valley, and by 1800, there were 4,402 white settlers and 288 slaves living in Brooke County, which included present-day Hancock County. During the 19th century, county residents focused on producing surplus goods for sale at the market. Among the earliest towns in the county were Hollidays Cove, Fairview (which became New Manchester), and New Cumberland. The shopkeepers and blacksmiths of those towns primarily served the farming economy. Local farmers found that apple orchards and sheep were well suited to the climate and hilly terrain. The annual arrival of apple-picking crews and the shearing of the sheep punctuated life in the county. During the early 20th century, the market for the county's wool and apples declined rapidly, but commercial farming in Hancock County has persisted to the present day.

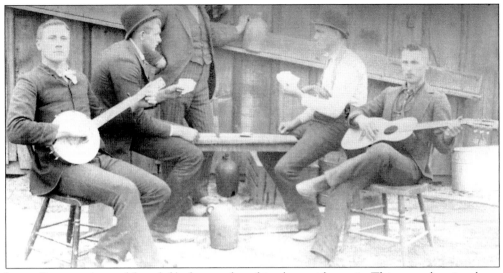

James Cameron (second from left) plays cards as friends provide music. This was taken in a barn in downtown Pughtown (also known as New Manchester), where the home of Dick and Doris Cameron is now located. (Courtesy of Dick and Doris Cameron.)

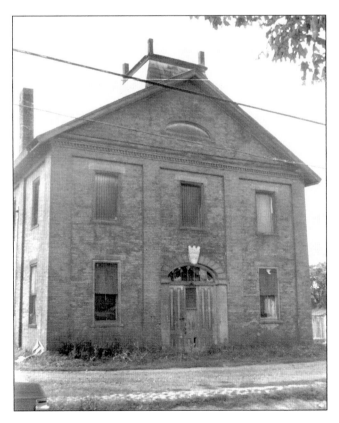

The former Hancock County Courthouse in New Manchester was built in 1850. After some controversy, voters chose to locate the county seat in New Manchester, or Fairview as it was called, where it remained for the next 31 years. When the county seat moved to New Cumberland, the old courthouse housed a business school and later a feed store. When first built, it featured a steeple that was gone by the time of this photograph. (Courtesy of the Hancock County Historical Museum.)

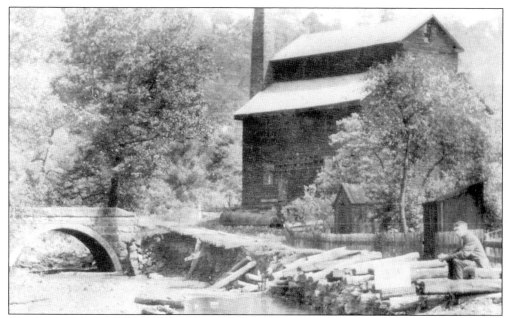

The Stewart Grist Mill was located by the stone bridge on Hardins Run Creek. A flood had wiped out the narrow-gauge track used by the Marquet Coal Company. (Courtesy of Joyce Frain, *Hancock County Courier.*)

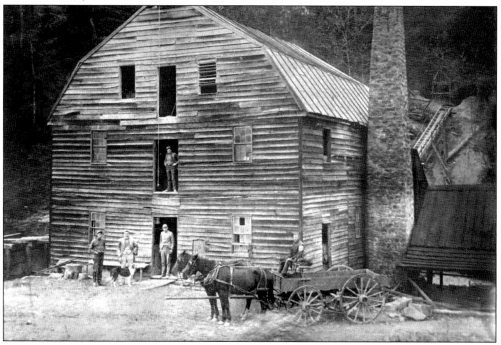

The Hartford Mill on Tomlinson Run was near the opening of a coal mine. The mill was originally owned by John B. Newell, who made flatboats on which to ship the flour from the mill and leather from his tannery down to New Orleans. Newell sold the mill to the Hartfords in 1850. Shown are John Hartford and his three sons, John Jr., Ross, and Ernest. On the wagon are Randolph Hobbs and his son Leonard. (Courtesy of Mrs. Dean Watson.)

Pictured here are crews of apple pickers on the Cowl Farm in the early 1900s. The Cowl family came from Pittsburgh and bought what was then a potato farm, but they soon began growing apples. The Willow Twig apple that the county's orchards developed and produced is not particularly sweet but is an excellent cooking apple. (Courtesy of Catherine Cowl Watson and Pat Cowl Law.)

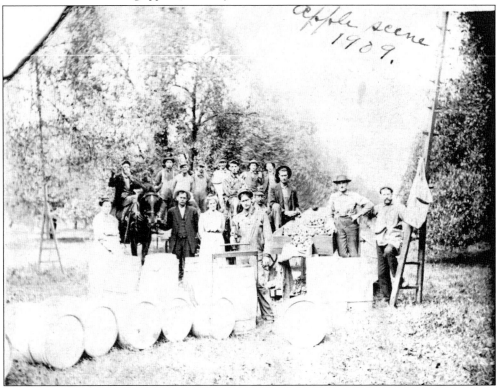

The fruit house on the Cowl Farm was constructed in the 1860s to store harvested fruit and still stands today. (Courtesy of Catherine Cowl Watson and Pat Cowl Law.)

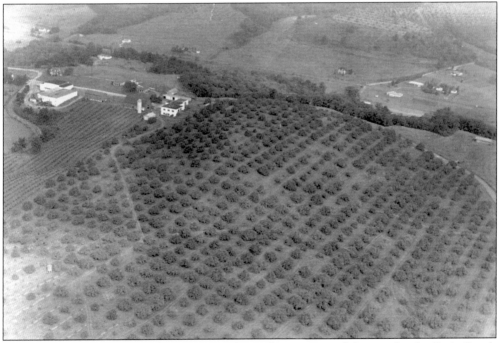

This aerial photograph of Hillcrest Farms shows the vastness of their orchards. C. A. Smith started Hillcrest Farms in 1917 and began breeding Hereford cattle on the farm the following year. He produced many champion bulls in the 1940s and 1950s. (Courtesy of the Hancock County Historical Museum.)

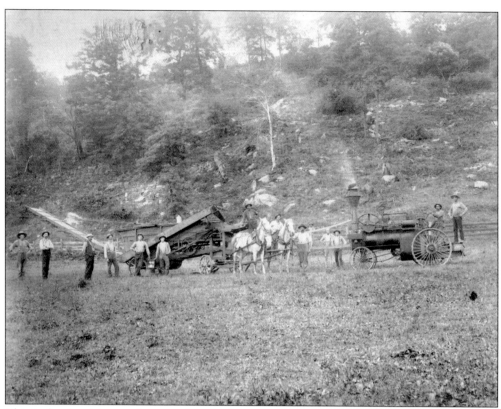

This is the threshing machine used in the farming area along the Tomlinson Run backwaters, including the Watson Farm (near present-day Route 2), in the early 1900s. (Courtesy of Alice Mitchell.)

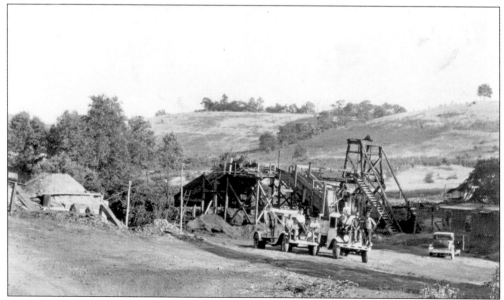

This portal to the coal mine operated by the Arner family gave Arner Mine Road its name. (Courtesy of the Arner Funeral Chapel.)

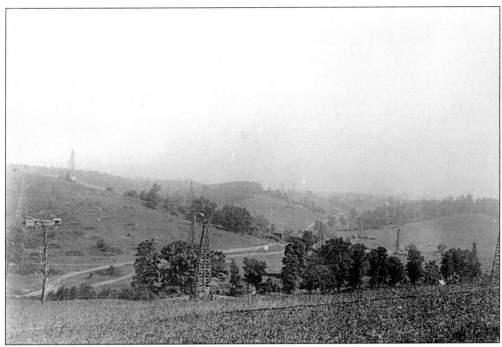

At the Carson oilfields near New Manchester in 1905, fifteen rigs produced 10 to 150 barrels per day. The fields covered 1,000 acres and were drilled by Murray and Miller Company of Chester. (Courtesy of Jack and Brian Carson.)

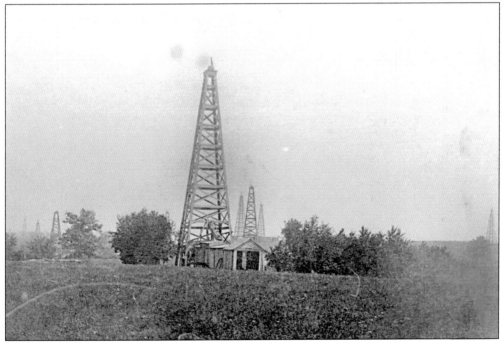

This image shows 10 of the 100 oil-producing rigs in the Carson oilfields. This field was part of the old Carson farm and was leased for drilling by Hock Brothers of Pennsylvania. (Courtesy of Jack and Brian Carson.)

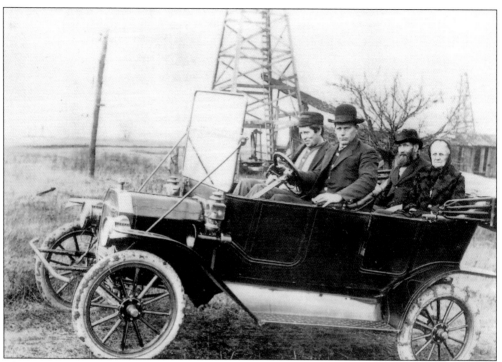

The Carson family driving through the oilfields includes, from left to right, Frank, Harry (driving), James, and Harriet Carson. (Courtesy of Jack and Brian Carson.)

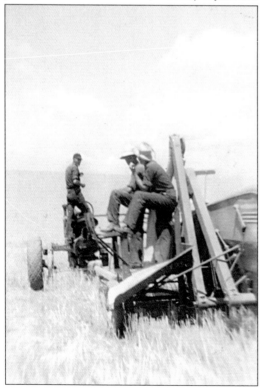

Bob Carson uses the brand-new McCormick-Deering combine for the first time on the Chambers Farm on Tope Hill. Also pictured are Jack Carson and a representative from the tractor company. (Courtesy of Jack and Brian Carson.)

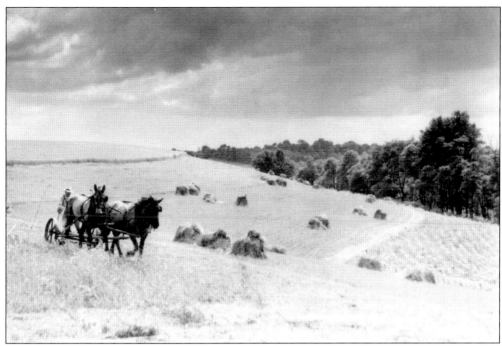

Hay is being cut on the Edgar Chambers farm in July 1947. Shown are strips of corn, hay, oats, and grass. (Photograph by A. F. Hallowell; courtesy of Jack Gibson.)

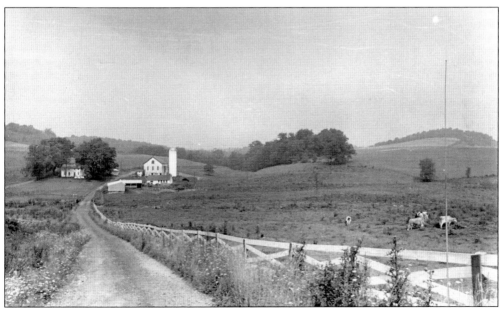

The Green Valley Dairy, located just across the Pennsylvania border, delivered milk to Hancock County residents for many years. (Courtesy of the Hancock County Historical Museum.)

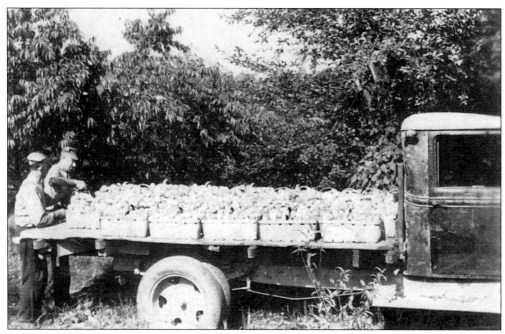

In the 1930s, the Cowl family switched from apples to peaches. Here we see crates of peaches loaded onto the family's flatbed truck. The Cowl Farm grew peaches for more than 30 years. (Courtesy of Catherine Cowl Watson and Pat Cowl Law.)

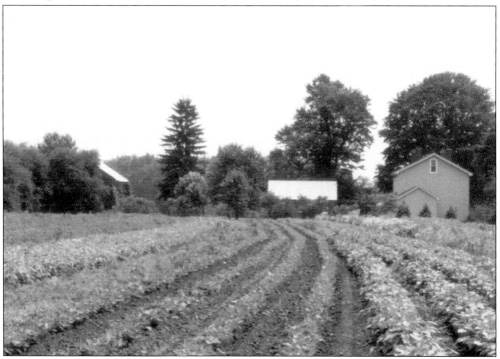

Some things on the Cowl farm have not changed. The fields and the farmhouse appear in this modern photograph much as they did in the 19th century. (Courtesy of Catherine Cowl Watson and Pat Cowl Law.)

A car drives up old Route 66 (present-day State Route 2, below the John D. Rockefeller Vo-Tech Center). Some members of Nessly Chapel formed a separate congregation and held their services in the white building in the distance. (Courtesy of Catherine Cowl Watson and Pat Cowl Law.)

A road construction crew improves Route 66, which had dangerous curves that were responsible for several automobile accidents before they straightened the road. (Courtesy of Catherine Cowl Watson and Pat Cowl Law.)

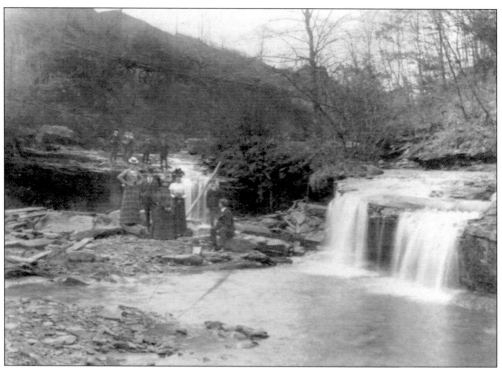

Young people gather at Sheep Hole near New Cumberland. It is possible that, like at other "Sheep Holes" around the country, nearby shepherds drove their flocks into this natural pool to clean the wool in the spring, right before shearing time. (Courtesy of the New Cumberland Municipal Building Collection.)

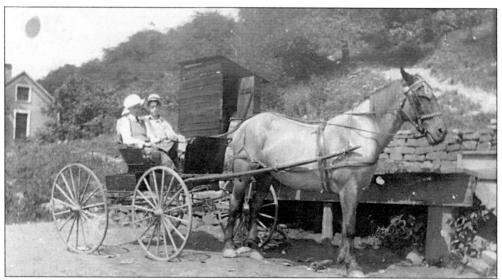

Riding in a Mackeys horse and buggy are Dean Watson (left) and Bert Dunlevy. The first automobile in Hancock County was purchased around 1903, but it was not until the 1920s that the affordable Model T Ford supplanted the horse and buggy as the popular mode of transportation. (Courtesy of Alice Mitchell.)

Two

NEW CUMBERLAND

John Cuppy founded New Cumberland in 1784 and originally named it Cuppytown, but he renamed it Vernon in 1839 when he laid out the town into 42 lots. Early buyers suggested the name New Cumberland, and Cuppy consented. Several investors in the late 1830s and 1840s took advantage of the veins of clay that ran underneath the area and opened clay mines in surrounding hills and brickyards on the river, and the town became known as Brickyard Bend. By 1877, there were a dozen brick, firebrick, sewer pipe, tile, and other clay product manufacturers in New Cumberland.

Capt. John Porter led the town's industrial development during the 19th century. Porter, a riverboat captain who operated a line of barges and steamships, became a part-owner of a handful of brick concerns in New Cumberland. He was also instrumental in bringing the railroad to the county in the 1880s. In 1890, fully one-third of the county's population, 2,305 people, lived in New Cumberland.

In addition to the brick works, New Cumberland also boasted the Chapman Foundry as well as the Hancock Manufacturing Company, a metal fabrication plant. However, seemingly annual floods and fires discouraged further industrial expansion. Mack Manufacturing of Philadelphia acquired several local potteries and modernized clay mining operations but in 1906 shut down three of the sewer pipe plants: the Clifton, Sligo, and Eagle Works. After 1890, the population slowly declined and leveled off at just over 1,800 souls by 1910. But as Mayor Jack Harris put it in the 1980s, "I doubt if the citizens in New Cumberland would change what we already consider to be the good life."

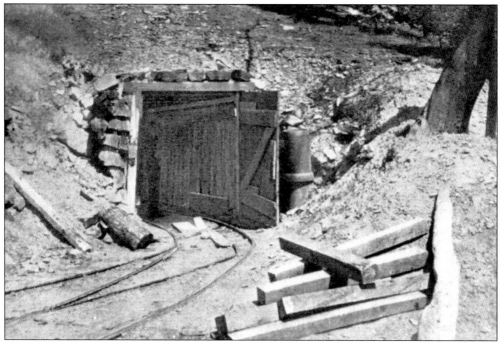

The Crescent Brick Clay Mine dates to 1856 and was started by two business partners named Atkinson and Garlick. Clay from the mine was well known in the industry for its superior quality. (Courtesy of the C. Atkinson Collection.)

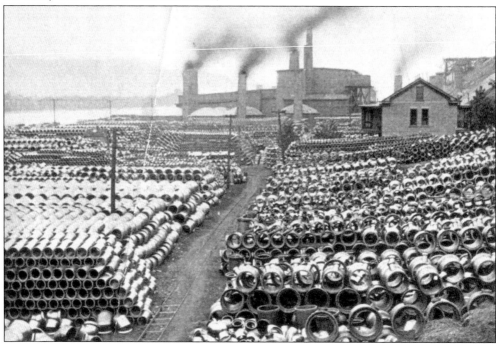

The Clifton Works and Office, located in the northern end of New Cumberland between the Ohio River and State Route 2, began around 1876 and used natural gas to fire the kilns. (Courtesy of the C. Atkinson Collection.)

A row of brick kilns belonging to Mack Manufacturing sits north of New Cumberland. Old Route 66, now State Route 2, runs along the hillside across from the kilns. (Courtesy of the C. Atkinson Collection.)

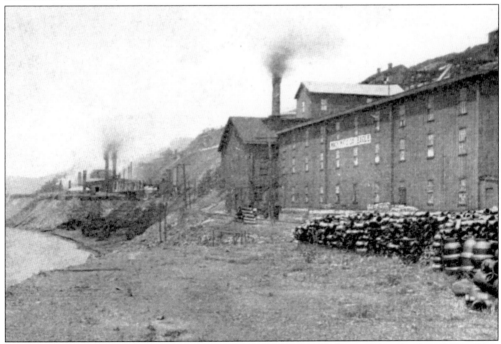

Eagle Sewer and Pipe Works was one of the several brickyards located in "Brickyard Bend," as New Cumberland became known. The companies made vitrified, glazed sewer pipes. (Courtesy of the C. Atkinson Collection.)

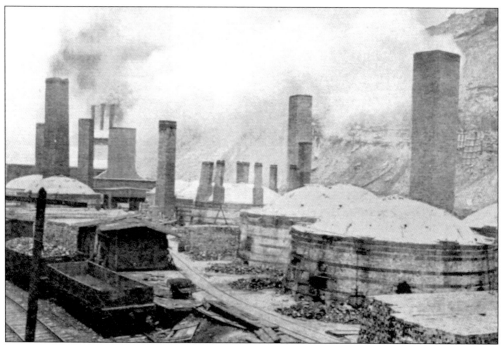

In 1844, Thomas Freeman built the Etna Works and mined clay from two different seams. The company was later purchased by Mack Manufacturing in 1894. Fire broke out at the Etna Works in 1900 and then again in 1907. (Courtesy of the C. Atkinson Collection.)

The Mack Manufacturing Company made vitrified brick and block for street paving, Diamond Brand Ohio River salt-glazed sewer pipe, flue lining, chimney tops, and other clay products. (Courtesy of the C. Atkinson Collection.)

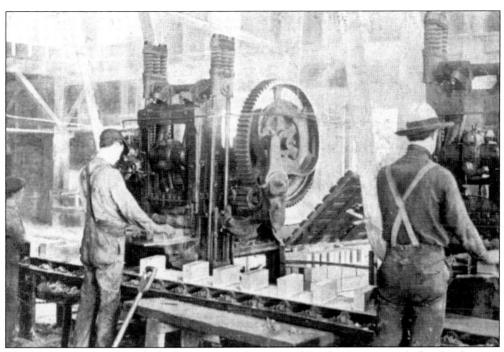

The brick presses at the Mack plant were used in one of the final processes before bricks were taken to kilns to be fired. The bricks were later loaded onto riverboats and rail cars to reach their final destinations. (Courtesy of the C. Atkinson Collection.)

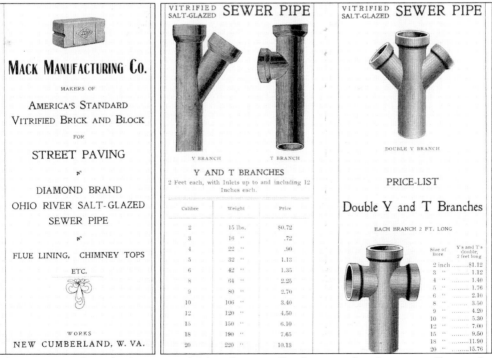

MACK MANUFACTURING CO.

MAKERS OF

AMERICA'S STANDARD
VITRIFIED BRICK AND BLOCK

FOR

STREET PAVING

DIAMOND BRAND
OHIO RIVER SALT-GLAZED
SEWER PIPE

FLUE LINING, CHIMNEY TOPS

ETC.

WORKS

NEW CUMBERLAND, W. VA.

VITRIFIED SALT-GLAZED **SEWER PIPE**

V BRANCH T BRANCH

Y AND T BRANCHES
2 Feet each, with Inlets up to and including 12 Inches each.

Calibre	Weight	Price
2	15 lbs.	$0.72
3	16 "	.72
4	22 "	.90
5	32 "	1.13
6	42 "	1.35
8	64 "	2.25
9	80 "	2.70
10	106 "	3.40
12	120 "	4.50
15	150 "	6.10
18	190 "	7.65
20	220 "	10.13

VITRIFIED SALT-GLAZED **SEWER PIPE**

DOUBLE V BRANCH

PRICE-LIST

Double Y and T Branches

EACH BRANCH 2 FT. LONG

Size of Bore	Y's and T's double, 2 feet long
2 inch	$1.12
3 "	1.12
4 "	1.40
5 "	1.76
6 "	2.10
8 "	3.50
9 "	4.20
10 "	5.30
12 "	7.00
15 "	9.50
18 "	11.90
20 "	15.76

These pages are from the 50-page Mack Manufacturing Catalog printed in their main offices in the Fidelity Building in Philadelphia in the early 1900s. (Courtesy of the C. Atkinson Collection.)

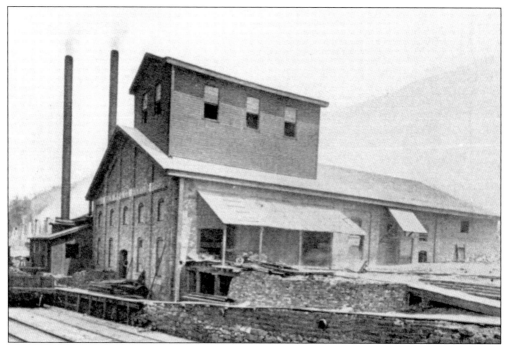

In 1870, Evans and Shane built the Rockyside Brick Plant, which mainly produced paving brick. (Courtesy of the C. Atkinson Collection.)

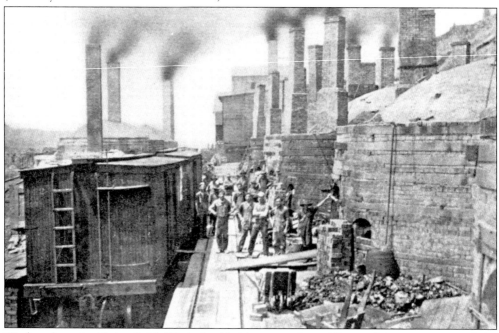

Workers from the Union Brick Works load bricks into railcars. Thomas Manypenny started the company in 1868. It was located along the Ohio River across from the New Cumberland Locks and Dam. John Porter later owned the works, which were in turn sold to Mack Manufacturing and changed to Crescent Brick. It was the last working brickyard in New Cumberland. (Courtesy of the C. Atkinson Collection.)

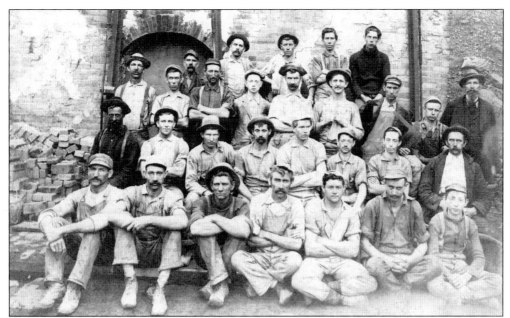

Pictured is the Globe Brick yard crew including, from left to right, (first row) Bill Orman, Charley Thomas, Charley Higgins, James McBean, Ernest Gibbs, Ben Ray, and Amy Boyles; (second row) Jack Jacobs, Billy Gillis, Paul Sadas, John Hart, Bill Stewart, James Dunlevy, George Dunlevy, and Bob McCafferty; (third row) Frank Troop, unidentified, Bob Heffner, Lonnie Boyles, John Davy Stewart, Andy Miller, Ross Hartford, Roy Robb, and an unidentified brick inspector; (fourth row) Albert Gaston, Charley Burris, Lawrence Swearingen, and Lew Thomas. (Courtesy of Alice Mitchell.)

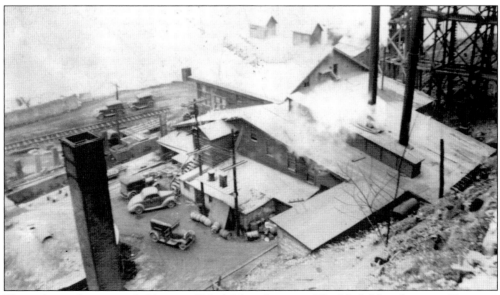

These clay works were probably part of Mack Manufacturing. The Mack Manufacturing Company of Philadelphia bought and consolidated the Rockyside, Union, Eagle, Etna, Crescent, Clifton, and Sligo brick companies. (Courtesy of George Hines.)

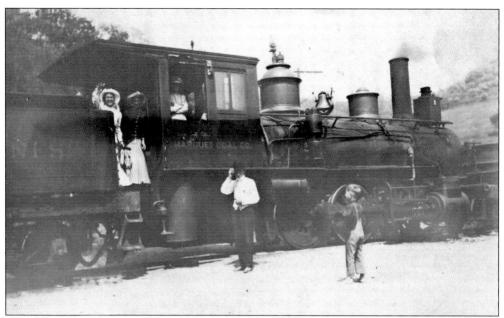

Using a narrow-gauge line, the Marquet Coal Company brought coal out of the mines on Hardins Run Road and through the city of New Cumberland. (Courtesy of George Hines.)

New Cumberland High School's class of 1905 included, from left to right, (first row) Elizabeth Gray, Professor Fritz, and Julia Plattenburg; (second row) George Crewson, Ana Patterson, and Annie Cullen. (Courtesy of the New Cumberland Municipal Building Collection.)

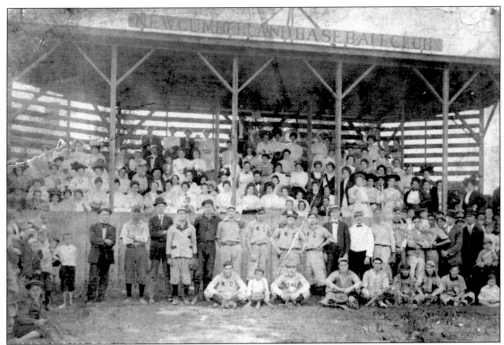

This photograph, taken on September 7, 1908, shows the New Cumberland Baseball Club, who played their games at the city fields in Eden Valley and on Third Avenue. (Courtesy of the New Cumberland Municipal Building Collection.)

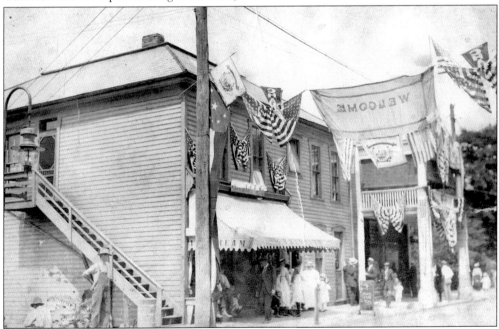

A chautauqua festival was held in 1915 at this building at the corner of Ridge Avenue and Clay Street. The Buford grocery store also housed the McFadden pharmacy and a barber shop. As part of the chautauqua movement, orators, performers, and educators traveled a national circuit to small towns and cities across the United States. (Courtesy of Mr. and Mrs. Bill Watson.)

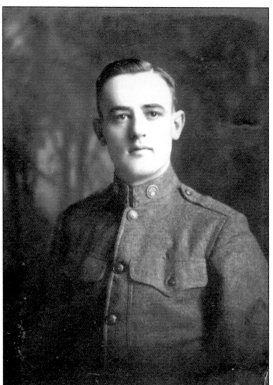

James C. Walton was born on September 5, 1895, in New Cumberland, the son of J. C. and Ila Marshall Walton. He served in the army during World War I and is pictured here in his uniform. After the war, he became a pharmacist in New Cumberland and Weirton, the profession from which he ultimately retired. (Courtesy of Louis C. Martin.)

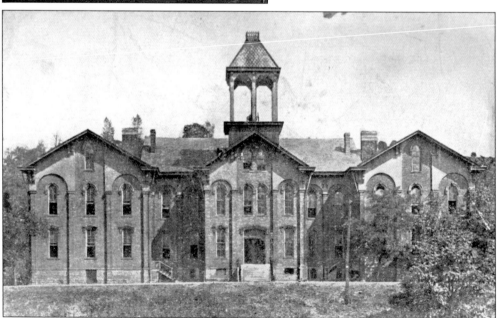

Built in 1869, the old New Cumberland Public School, nicknamed the Gravel Hill Academy, was located on North Court Street next to the courthouse, overlooking the town. It contained six rooms until the north and south wings were added in 1883. This building burned in 1939 and was replaced by a new school, which now houses the municipal complex. (Courtesy of the New Cumberland Municipal Building Collection.)

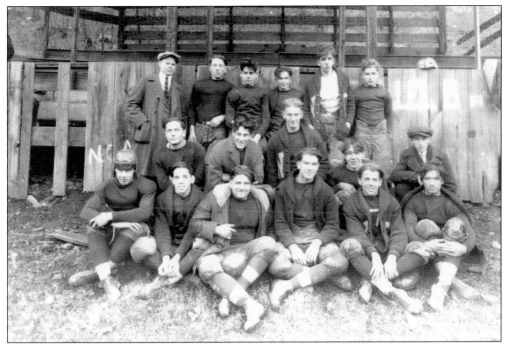

One of New Cumberland High School's earliest football teams is pictured in 1925 in Eden Valley with their coach, Chick Roach, standing on the far left. (Courtesy of the New Cumberland Municipal Building Collection.)

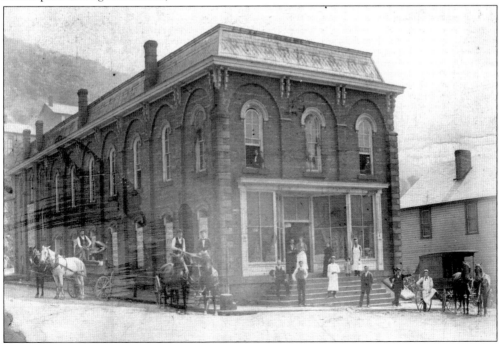

Mack Manufacturing built a general store on Pearl Street in 1906. It was later called the People's Store and eventually became the A&S grocery store. It burned in 2005. (Courtesy of the New Cumberland Municipal Building Collection.)

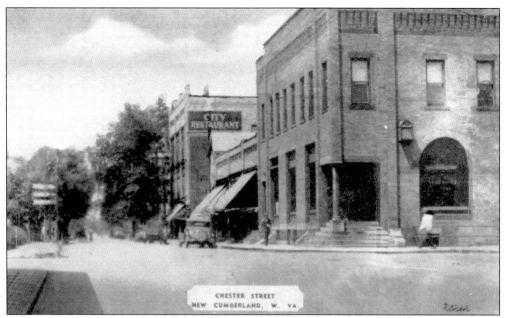

The Graham Department Store on the right was the focal point of the city's downtown. In early years, it housed the First National Bank, the post office, a barber shop, and doctor and dentist offices. (Courtesy of the New Cumberland Municipal Building Collection.)

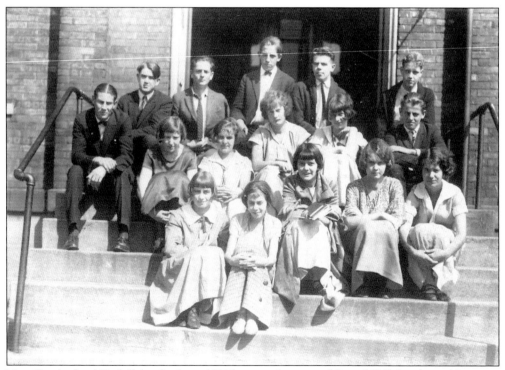

New Cumberland High School's class of 1925 sits on the steps of Gravel Hill Academy. (Courtesy of Bill and Virginia Owings.)

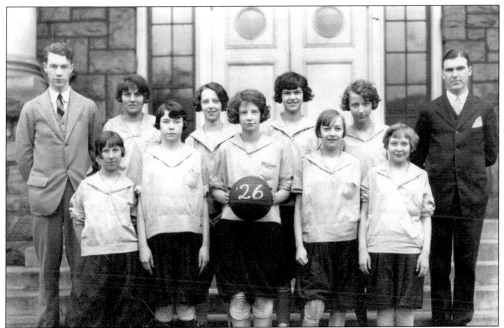

The girls' basketball team of 1926 stands in front of the courthouse. From left to right are (first row) Lydella Hahn, Neva Gibson, Jane Atkinson, Mim Powell, and Irene Luke; (second row) Fred Atkinson, Ruth Moore, Mary Porter, Betty Brandon, Jane Cullen, and Virgil Roach. (Courtesy of Joyce Frain, *Hancock County Courier*.)

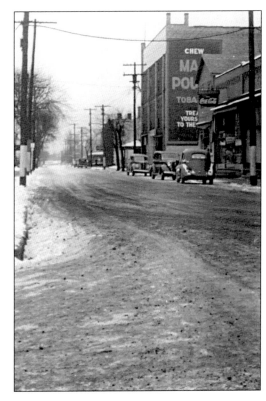

This photograph from 1935 shows Chester Street looking north. The building with the Mail Pouch advertisement was the Huff and Bloom Building, which once contained various businesses. The Masonic Lodge was on the third floor. (Courtesy of Bob McNeil.)

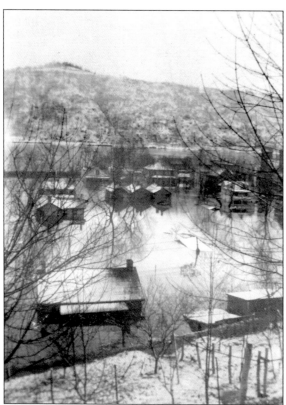

New Cumberland has suffered numerous floods, but the 1936 flood was the most devastating. On March 18, the infamous 1936 flood hit the upper Ohio Valley, and it is still talked about today. Flood stage in New Cumberland ranges from 34 to 39 feet in different sections of town. In 1936, the water crested at a record 51.6 feet. (Courtesy of the Hancock County Historical Museum.)

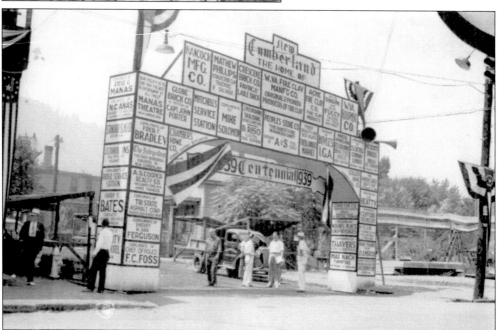

In 1939, the citizens of New Cumberland celebrated the town's 100th anniversary with various activities. A centennial arch was built across Madison Street near where the traffic light is today. (Courtesy of the New Cumberland Municipal Building Collection.)

On September 1, 1942, the World War II Eagle Honor Roll at the bottom of Station Hill was dedicated to all servicemen from the New Cumberland area who were serving their country. (Courtesy of the New Cumberland Municipal Building Collection.)

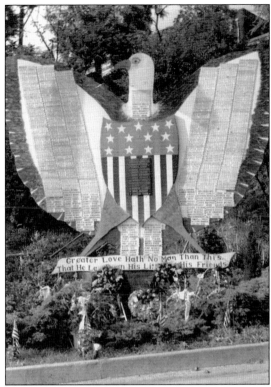

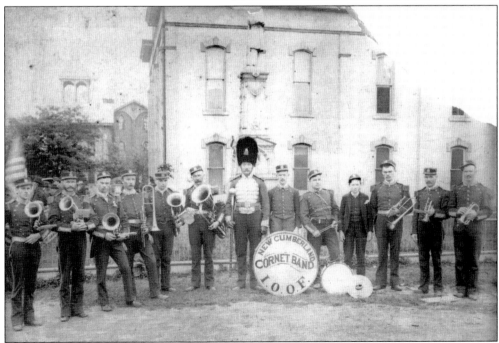

The New Cumberland Cornet Band from around 1918 is shown standing in front of the courthouse. It was sponsored by the local Independent Order of Odd Fellows (IOOF). (Courtesy of the New Cumberland Municipal Building Collection.)

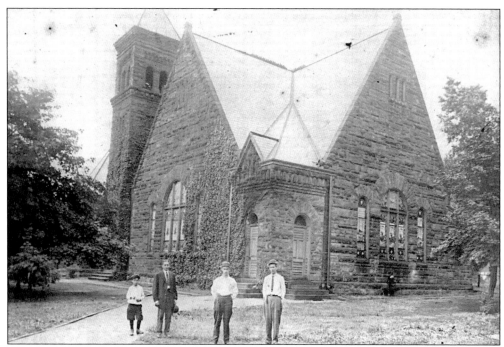

The New Cumberland First United Presbyterian Church was organized on May 7, 1851, and built the "stone church," as they called it, in 1888 from stone quarried along Hardins Run Creek. (Courtesy of the New Cumberland Municipal Building Collection.)

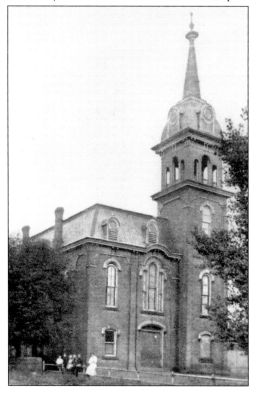

Built in 1874 and dedicated in 1886, the New Cumberland First Christian Church had met in several locations before this building was erected. The congregation first organized around 1840. (Courtesy of the New Cumberland Municipal Building Collection.)

In 1939, the Hancock County Courthouse was in its third building in the same location. The first had been torn down in 1905, and the second burned in 1920. The ivy no longer adorns the present structure. (Courtesy of Bob McNeil.)

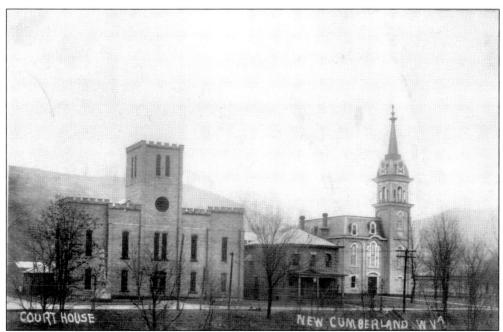

The second courthouse was between the school and the Christian church. To the right are the former jail and the sheriff's office. (Courtesy of the New Cumberland Municipal Building Collection.)

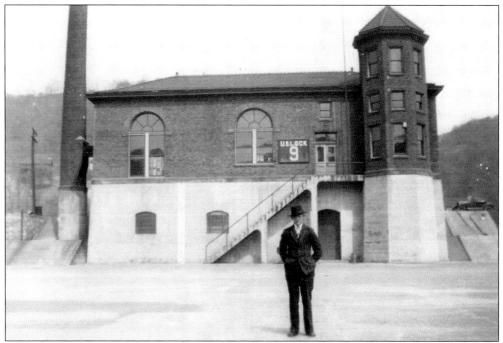

Old Lock No. 9 was built in the early 1900s and completed in 1914 across the road from the old lock and dam houses. Burns McNeil is shown in front of the building. (Courtesy of Bob McNeil.)

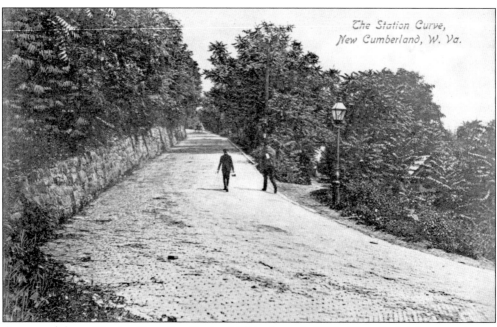

A postcard shows "Station Curve" or Station Hill in the early 1900s. Note the brick street, the gas lamp, and what appears to be an overgrowth of sumac trees on both sides of the street. Coming down the hill in the distance is a horse and buggy. (Courtesy of Krista S. Martin.)

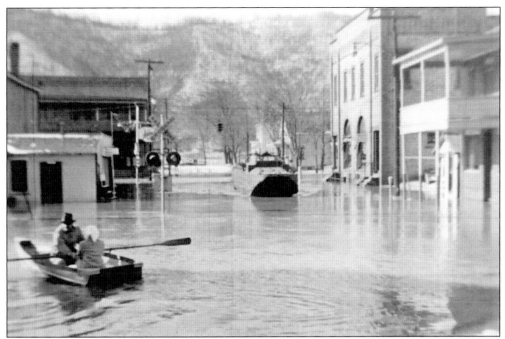

On January 23, 1959, the Ohio River crested at 39.9 feet and covered much of downtown New Cumberland. The boat in the background, an army "duck," could drive on land or water and was used for years during floods. (Courtesy of the New Cumberland Municipal Building Collection.)

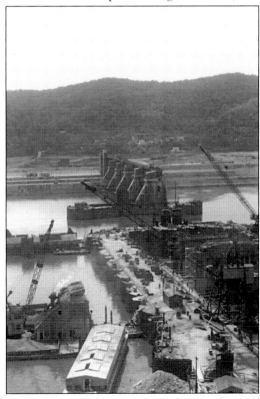

Located north of the Crescent Brick Works, the new U.S. Lock and Dam No. 9 was completed in 1961. The locks are located in Stratton, Ohio, due to the lay of the land in New Cumberland. (Courtesy of the New Cumberland Municipal Building Collection.)

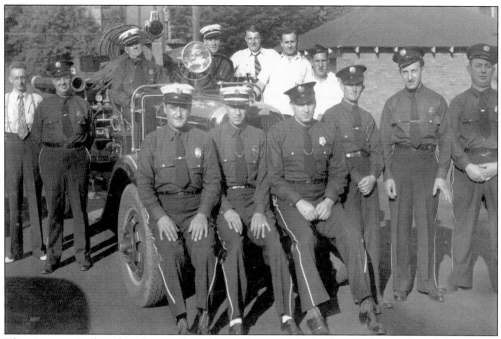

The city acquired its first fire truck in 1932. Shown with the fire truck are, from left to right, (first row) Charles Berardi, William Powell, William Theiss, Wylie Smith, George Bright, and Nick Nardo; (second row) John McAtee, Albert McAtee, E. L. Hood, Chief D. R. Turley, Dean McAtee, Patsy Guerrera, and Bill Cullen. (Courtesy of Joyce Frain, *Hancock County Courier.*)

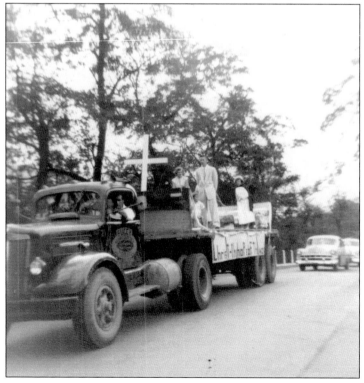

A Fourth of July parade in the late 1950s shows a Fuccy truck hauling a float for a local church with a banner that reads "Christ—the hope of the world." (Courtesy of Linda Hawkins.)

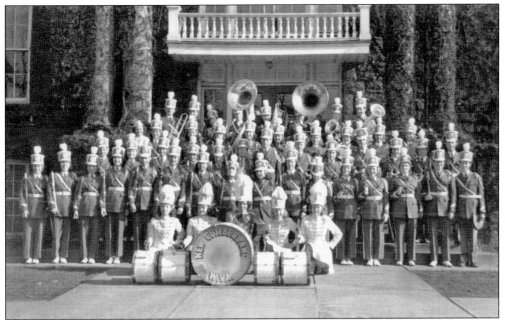

The New Cumberland High School marching band stands in front of the courthouse in 1952. The courthouse steps were used for many of the high school's photographs. (Courtesy of Doris Swain.)

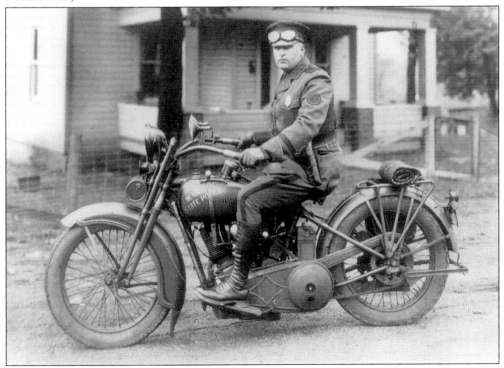

Robert Paul Harris Sr. sits on his West Virginia State Police motorcycle. He is the grandfather of former mayor Jack Harris and served in law enforcement in the 1940s and 1950s. (Courtesy of Sharon Harris Ulbright.)

This photograph of downtown New Cumberland in the 1960s was taken from Court Street. Notice that not much has changed except the new brick wall that replaced the old cable running along Station Hill. (Courtesy of the New Cumberland Municipal Building Collection.)

Three

CHESTER

The pottery industry in East Liverpool, Ohio, in the 1890s expanded to the point where there was little level land left in that city on which to build new potteries. Excavations for a new bridge across the Ohio River began in March 1896. Originally some called the prospective town across the river from East Liverpool "Southside" or "South Liverpool," but when developers formed the Chester Land Company, the name Chester stuck. The Chester Bridge was opened to the public on New Year's Eve, 1896. The next day, some 2,500 people paid a nickel to walk across it. Pottery companies were not far behind.

The Taylor, Lee, and Smith Company, which later became Taylor, Smith, and Taylor (TS&T), began construction of a pottery in Chester in 1899. By 1913, TS&T had 17 kilns in operation and employed about 400 people. The Edwin M. Knowles China Company built a second pottery in Chester in 1900. By 1907, it had seven kilns and employed over 500. In addition to potteries, the Chester Rolling Mill also started operations in 1900 producing tin plate and was quickly purchased by the American Sheet and Tin Plate Company, a national corporation.

Charles A. Smith became Chester's biggest booster. He was born in 1867 in Wellsville, Ohio, and got his start in nearby Pennsylvania oil fields. His brother, W. L. Smith, became one of the initial investors in the Chester Land Company, which drew Charles back to the Ohio Valley, where he purchased the Chester Bridge in 1901. Thereafter he continued to expand his business interests in the area.

Before the Chester Bridge was built in 1896, very few people lived on the West Virginia side of this stretch of the Ohio River, especially when compared to East Liverpool, Ohio, in the distance. (Courtesy of the City of Chester.)

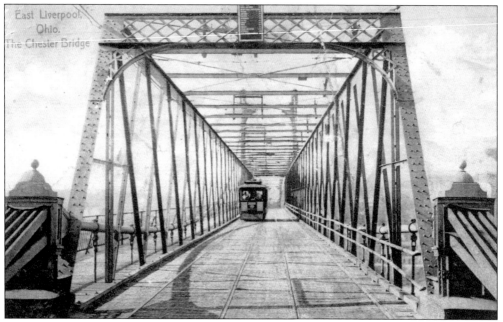

The Chester Bridge was completed on New Year's Eve, 1896, and streetcars began transporting people back and forth from East Liverpool to the factories of Chester in May 1897. For some time, only one driver, James McKinnon, serviced the line, making a round-trip every hour. (Courtesy of the Hancock County Historical Museum.)

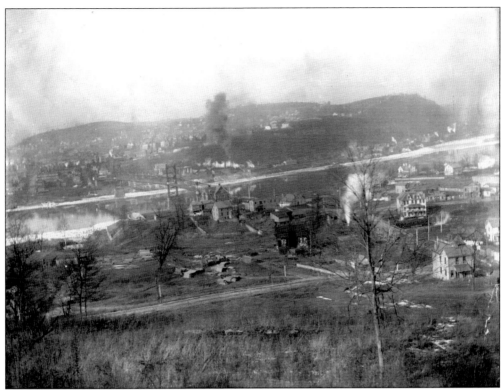

By 1905, less than 10 years after the Chester Bridge's completion, numerous houses had been constructed in the promising new pottery town. The smoke of the potteries and the rolling mills fills the sky on the horizon of the lower image. (Courtesy of the City of Chester.)

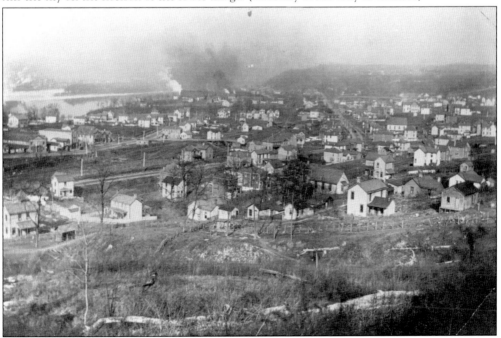

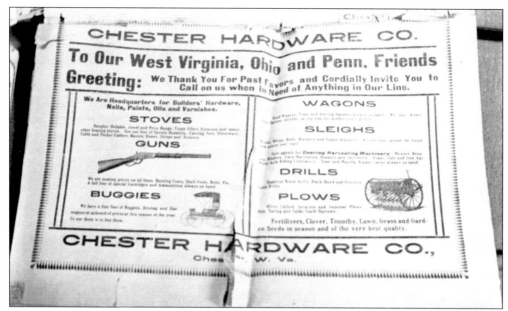

The nature of products being advertised by the Chester Hardware Company, including stoves, guns, wagons, plows, and seeds for clover and timothy, suggest that this advertisement came from early 1900s and that many customers were farmers. (Courtesy of the Hancock County Historical Museum.)

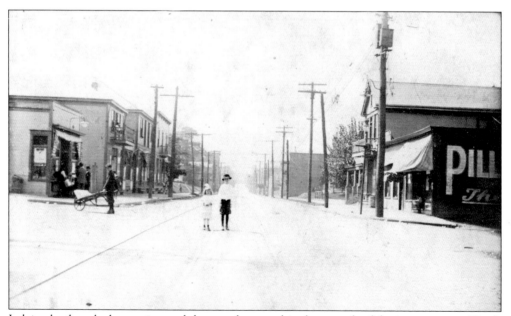

Judging by the telephone wires and the paved street, this photograph of the intersection of Sixth Street and Carolina Avenue may have been taken c. 1920, as the town's appearance became more refined. (Courtesy of the Arner Funeral Chapel.)

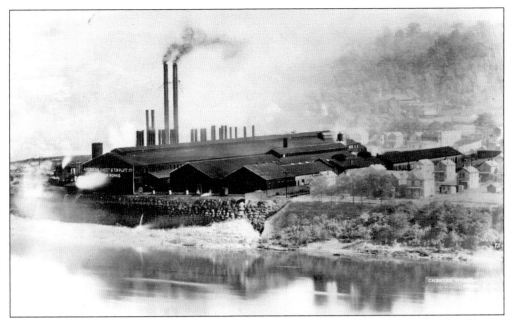

In 1900, William Banfield began building his second tin plate mill in Chester, his first having been built in Irondale, Ohio. The Chester Rolling Mill had just begun operations in 1901 when Banfield sold it to the American Sheet and Tinplate Company, a subsidiary of U.S. Steel. (Courtesy of the City of Chester.)

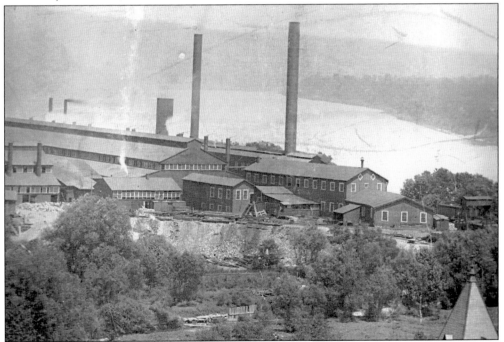

The Chester Rolling Mill is pictured here from another angle. Interestingly the workers at the Chester works initially formed a lodge of the Amalgamated Association of Iron, Steel, and Tin Workers, but their lodge did not survive the national 1901 strike against U.S. Steel. (Courtesy of the Hancock County Historical Museum.)

From this angle of the Chester Rolling Mill, we can see railroad cars entering the plant. It stayed in operation from 1901 through 1931, when it was deemed obsolete as well as located on a lot that was too small for expansion. (Courtesy of the Arner Funeral Chapel.)

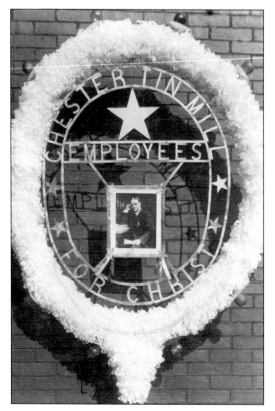

This Chester Tin Mill Employees for Christ wreath appears to feature a portrait of Billy Sunday, the professional baseball player turned born-again evangelist who gained prominence in the early 1900s for promoting the Young Christian Men's Association (YMCA) and later for giving "fire-and-brimstone" sermons on the radio. (Courtesy of the Hancock County Historical Museum.)

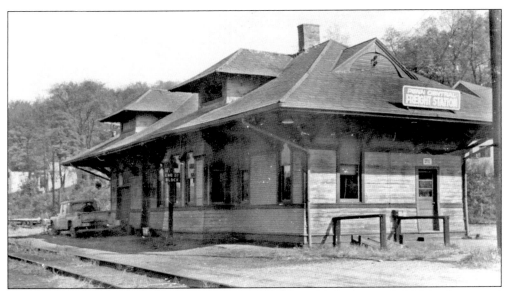

Here is the Penn Central Freight Station. In a pamphlet published around 1905 (and reprinted in Roy Cashdollar's *A History of Chester*), C. A. Smith touted Chester's advantages by noting that "Pennsylvania lines are just completing an extension of the Panhandle system through the town." (Courtesy of the Hancock County Historical Museum.)

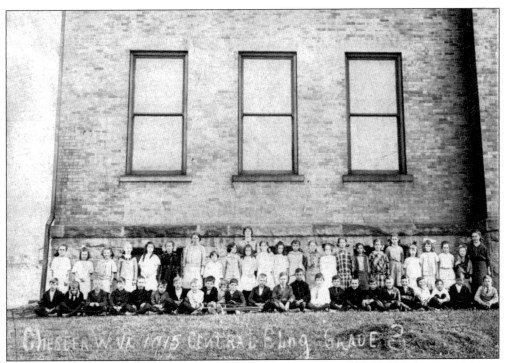

Pictured above is the third grade of Chester Central School in 1915. Central School was built in 1906 at Third Street and Indiana Avenue. After schools consolidated, the building was abandoned in 1963 and razed in 1967. (Courtesy of the City of Chester.)

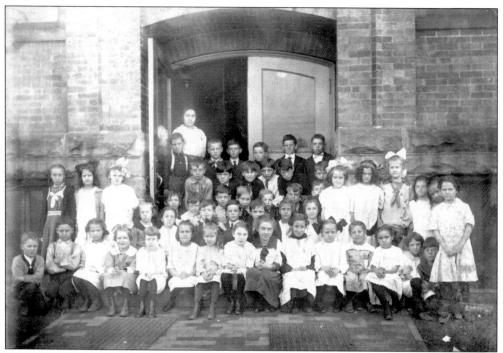

Second-grade students in Chester pose, possibly in 1914. The Chester Central School educated elementary students for over 50 years. The Chester High School was not built until 1926 at Sixth Street and Indiana Avenue. (Courtesy of the City of Chester.)

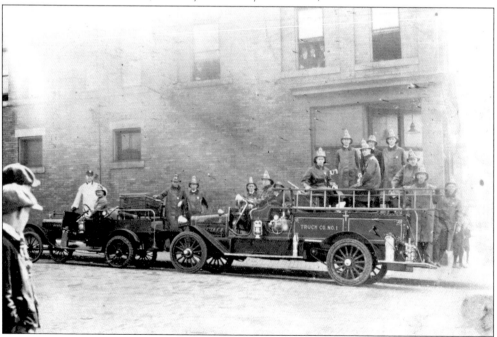

Pictured here is the Chester Fire Department in 1918. Their chief was Ernie Bonjour. The Chester Fire Department first purchased a Ford truck with a booster tank, then an American LaFrance truck in 1928. (Courtesy of the City of Chester.)

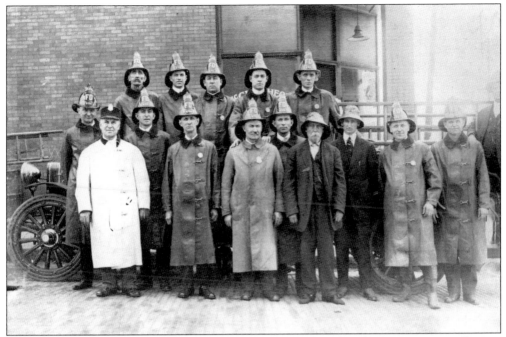

As early as 1898, the town had a list of volunteers to fight fires, but that system was ineffective. The formal Chester Volunteer Fire Department was established in 1913. This picture was probably taken in 1918. (Courtesy of the City of Chester.)

According to Roy Cashdollar, this picture of the Chester Fire Department was taken in 1922. (Courtesy of the City of Chester.)

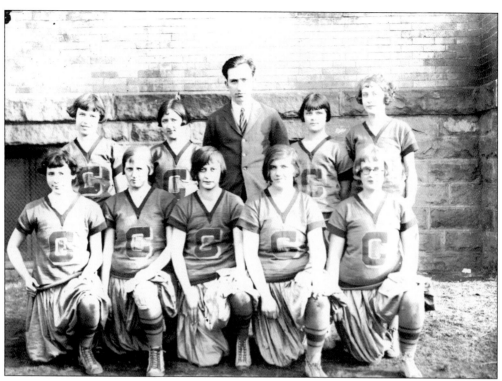

This is probably the Chester High girls' basketball team in 1924–1925. Chester High School had girls' basketball during the 1920s, but they did not always have a court for them. In 1927, they were forced to play their games in city hall. Andy Price coached many of the girls' teams. (Courtesy of the Hancock County Historical Museum.)

A handful of residents and the first priest in Chester chose the name Sacred Heart for the Catholic parish of Chester and its church in 1902. Construction of the rectory where mass was initially held was completed in August 1903. (Courtesy of the Arner Funeral Chapel.)

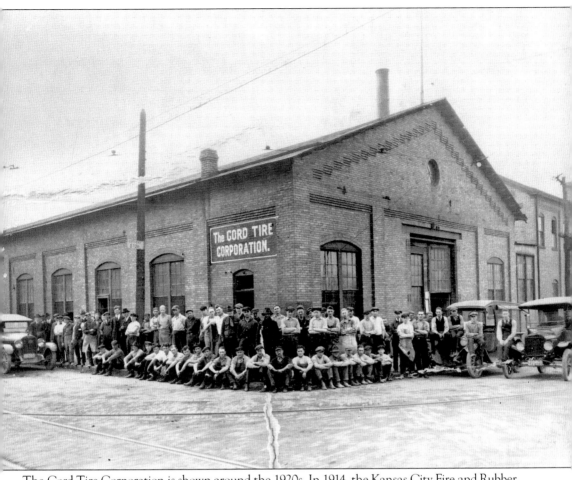

The Cord Tire Corporation is shown around the 1920s. In 1914, the Kansas City Fire and Rubber Company converted the building that housed the streetcars into a rubber factory. When that company went out of business a few years later, new investors began Cord Tire. The company employed 189 men and 31 women in 1926 but ceased operations in 1928. (Courtesy of George Allison.)

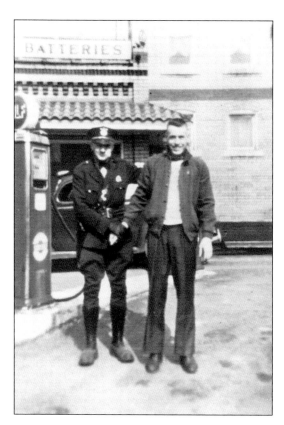

On the left is a young Chester police officer, Floyd H. "Doc" Lyons, in the 1930s. He was appointed chief of police in 1930, and for 20 years, he was Chester's only officer on duty. Pictured here is a lighter moment at Arner's Gulf station, outside of their funeral chapel. (Courtesy of the Arner Funeral Chapel.)

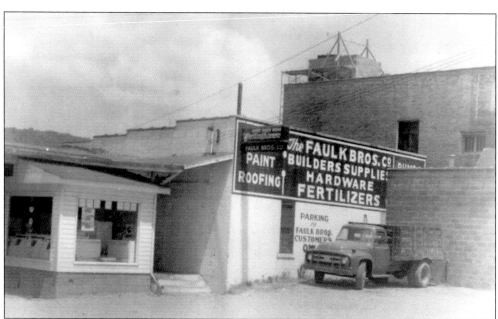

The Faulk Brothers Company, pictured here in 1957, was started in 1908. They originally milled, packaged, and sold flour. The company focused increasingly on hardware in later years. (Courtesy of the National Church Supply.)

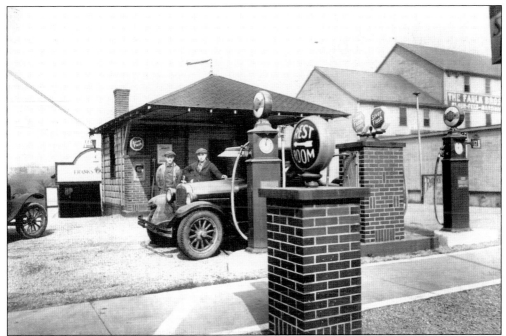

This Carolina Avenue Gas Station in the 1920s, based on signs in the photograph, appears to be Frank's Sunoco, but Roy Cashdollar explains in his *A History of Chester* that the service station next to Faulk Brothers was known as the Irwin Service Station. (Courtesy of the Hancock County Historical Museum.)

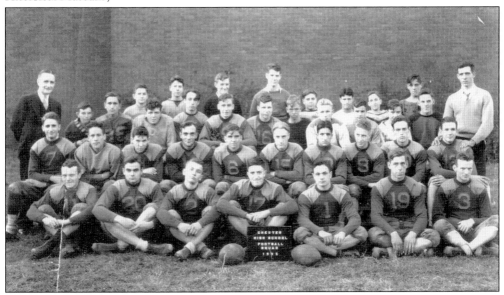

The 1935 Chester High School football team included, from left to right, (first row) Simcox, Mayhew, James, House, Gallo, Watson, and Vanaman; (second row) Dewell, Walker, Coe, Morris, Clutter, Fetty, Amedeo, Wilson, and Gilbert; (third row) Coach Tuttle, Ewing, Wilson, Reed, Reoykolf, Graham, Swearingen, Graham, Schonly, Bumbiro, Cashdollar, Allen, and Coach Ewing; (fourth row) Allison, Johnson, Bloor, Oyster, Managers, Clutter, Amedeo, Conklin, and Chaney. (Courtesy of the Hancock County Historical Museum.)

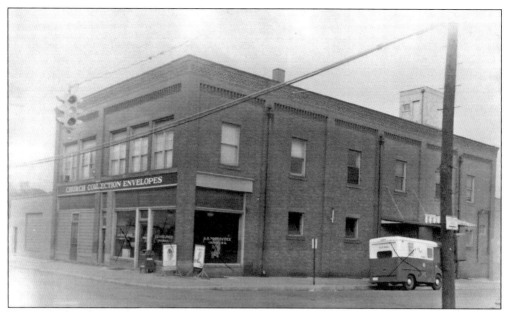

National Church Supply operated out of the M. E. Eppley Building, the front part of which was used for the post office for a few years. In 1915, Cyril Taylor, an English immigrant who painted dishes for a local pottery, founded National Church Supply, which makes and prints offering envelopes and bulletins for churches. (Courtesy of the National Church Supply.)

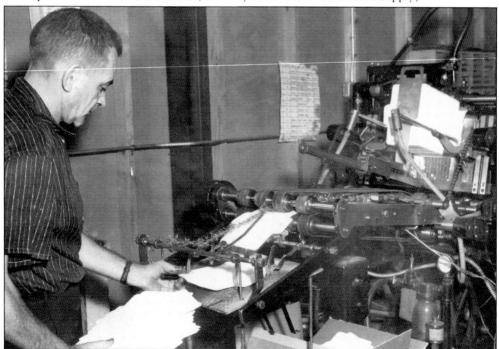

Bill Melott uses an old press at National Church Supply in the 1950s and 1960s. Today the company, located on Lawrenceville Road near Route 8, employs 150 people and is the largest multi-denominational supplier of church envelopes. Their newest press was made in Germany, cost $1.5 million, and can print 1,200 envelopes per minute. (Courtesy of the National Church Supply.)

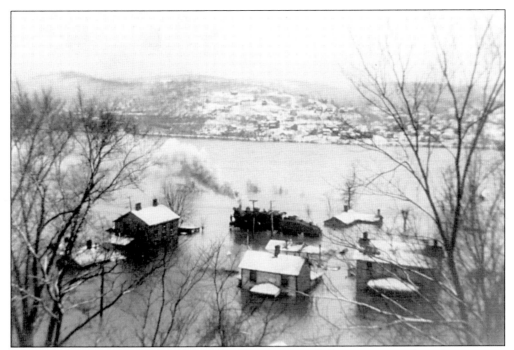

The 1936 flood devastated the Ohio Valley. This picture of a locomotive partly underwater was taken near Chester. (Courtesy of the Arner Funeral Chapel.)

This photograph, probably taken in the 1930s, gives a glimpse of the Arner Funeral Chapel at a time when the family also owned and operated a Gulf gas station on their property. G. A. Arner helped organize the town of Chester and served as one of its first councilmen. He was co-owner of a livery in the early 1900s before he started his mortuary business. In 1916, he purchased the building where the Arner Funeral Chapel is located today. (Courtesy of the Arner Funeral Chapel.)

Here George A. Arner Jr. marries Alma Scott before shipping out for World War II. According to National Archives records, he enlisted as a private in Huntington on July 5, 1941. His occupation was listed as "embalmer," and he had three years of college. He achieved the rank of first lieutenant before he was killed in action. Thirty-one Chester men and 111 from Hancock County in all lost their lives in World War II. The Chester American Legion Post 121 was named in memory of Arner, who was the first from Chester to die in the war. (Courtesy of the Arner Funeral Chapel.)

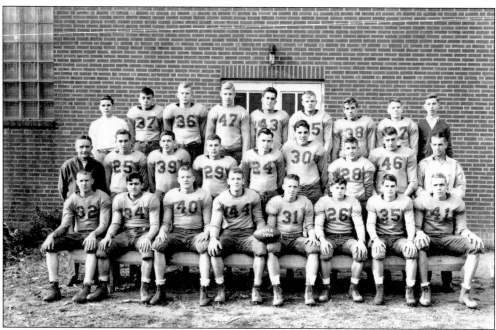

The 1944 Chester High football team was coached by Max Tuttle, standing at the far left of the second row. Tuttle coached the previous year's team to an undefeated record. (Courtesy of the City of Chester.)

This is most likely a picture of the memorable "Big Snow" of 1950. While many businesses closed, barber Paul Johnson managed to stay open. The weight of the snow buckled the McBee's Pottery building. (Courtesy of the Arner Funeral Chapel.)

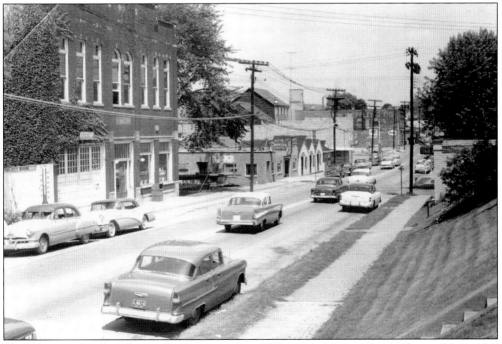

The Chester City Building is shown in the late 1950s. People's Finance is also visible in this photograph; Faulk Brothers peaks up from behind the Veterans of Foreign Wars building; and the Eppley Building is in the background. (Courtesy of the City of Chester.)

Harry Abrams's Chester News on the corner of Carolina Avenue and Fifth Street sold drinks, snacks, and penny candy in addition to newspapers. (Courtesy of the Hancock County Historical Museum.)

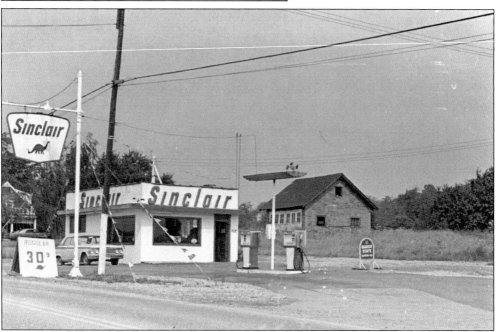

The Hilltop Sinclair gas station was on Route 30, the Lincoln Highway. Construction on the highway began in the 1930s and spawned numerous gas stations, motels, and souvenir stands. This station was still in business as late as the 1960s. (Courtesy of the Hancock County Historical Museum.)

William H. Werkheiser came to Chester from Mount Jewett, Pennsylvania, in 1909 and opened the Werkheiser's Hardware store on Plutus Avenue, above. While the businesses and buildings changed over the years, the Werkheisers persisted as owners and operators. William's grandson, Bill Werkheiser, joined the armed forces during World War II, after which he opened the present store on 200 Carolina Avenue, pictured below. (Courtesy of the Arner Funeral Chapel.)

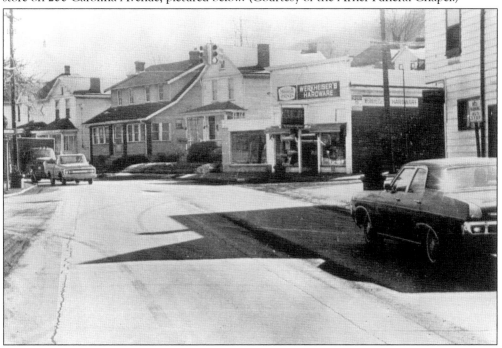

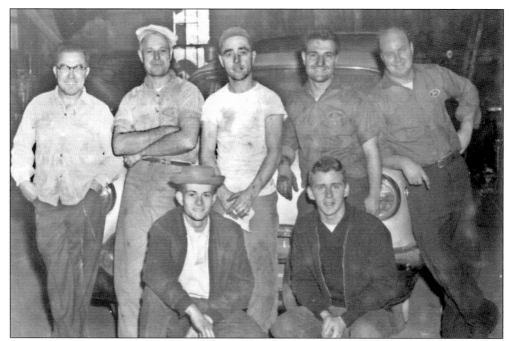

These men are hanging out in Ray Zorzi's Texaco Garage and Body Shop at Sixth and Carolina in the 1950s. Names written on the back of the photograph indicate that posing here are, from left to right, (kneeling) Pete Arner and Sid Martin; (standing) Ray Zorzi, ? Burlingame, Chub Coleman, Lou Cavallaro, and Jack Tainer (?). Zorzi operated his garage for more than 40 years; (Courtesy of the Arner Funeral Chapel.)

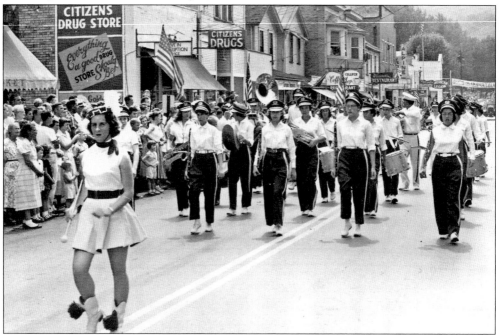

A parade marches past Citizens Drug Store, the Cullifer Coffee Shop, Weaver's Restaurant, and the Alpine Theater around the 1960s. (Courtesy of the City of Chester.)

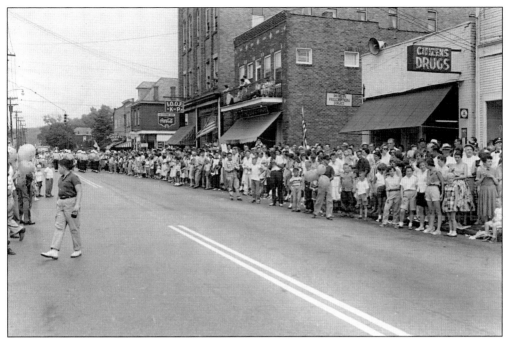

The same parade continues past Monongahela Power Company, the IOOF Hall, Chester News Depot, Pat's Tavern, and Fannie's Lunch. In the center of the photograph, residents watch from a balcony above a sign that reads "National Brands Markets." (Courtesy of the City of Chester.)

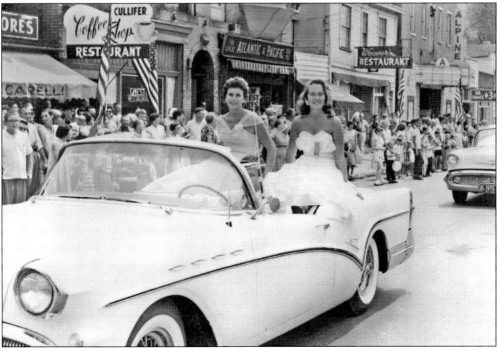

In this photograph of two lovely young ladies in a parade on Carolina Avenue around the 1960s, we can see Cullifer's Coffee Shop, the Great Atlantic and Pacific Tea Company, Weaver's Restaurant, and the Alpine Theater. (Courtesy of the City of Chester.)

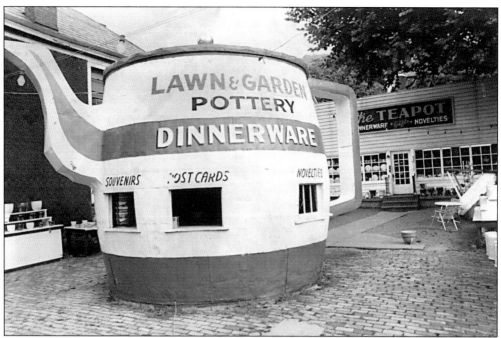

The Teapot store was located between First and Second Streets, next to a few "tourist homes," which were similar to today's bed and breakfasts and were popular during the 1940s and 1950s. The Teapot sold pottery, knickknacks, hot dogs, and lemonade, among other things. Later this teapot, the largest teapot in the world, was relocated to the green space beside the on ramp for the Jennings Randolph Bridge. (Courtesy of the Hancock County Historical Museum.)

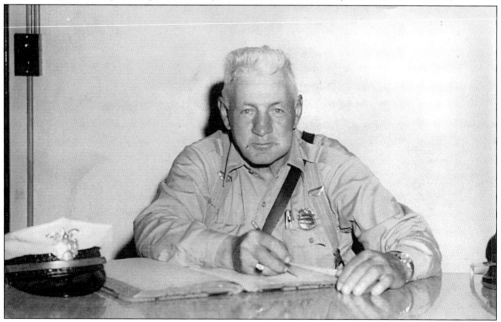

Doc Lyons sits at his desk, c. 1957. He retired on February 18, 1960, at the age of 66 after 30 years on the job. May 6 was declared "Doc Lyons Day" in Chester, and 200 attended an appreciation dinner at the Chester American Legion to mark the occasion. (Courtesy of the City of Chester.)

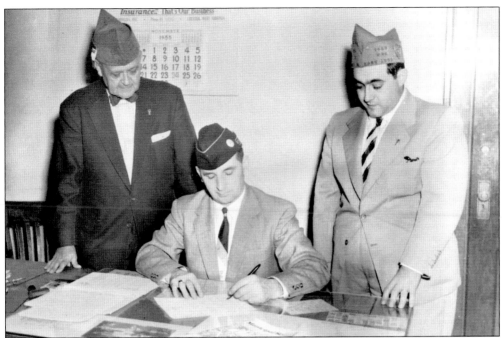

Community leaders in 1955 include, from left to right, Dr. Watkins, Mayor George Scott, and George LaNeve. Though his first name was not written on the photograph, the man on the left is probably Dr. Ralph D. Watkins, who was a dentist in Chester for over 30 years. (Courtesy of the City of Chester.)

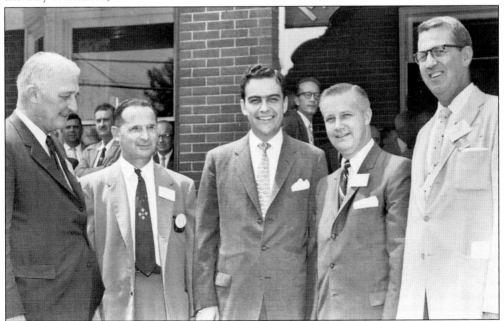

Mayor George Scott, second from left, poses with Republicans Cecil Underwood (center) and Arch Moore (second from right). This picture may have been taken in 1956, when Underwood was elected governor and Moore was elected to the U.S. House of Representatives. The other men may also be Republican Party officials. (Courtesy of the City of Chester.)

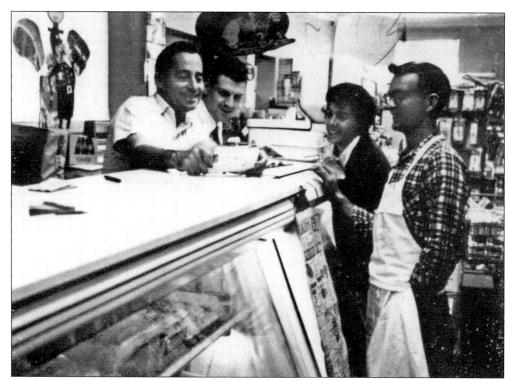

Standing at the meat counter of Russ Davis's IGA are, from left to right, Russ Davis, Jim Nicholson, Dean Davis, and Bill Fisher. Russ and Dean owned and operated the store for 20 years. (Courtesy of Dean Davis.)

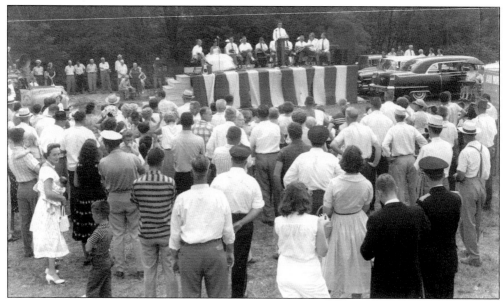

A man who appears to be Cecil Underwood gives a speech to a crowd in Chester. This was probably during his 1956 campaign. In the background on the left, a bullhorn is mounted to a vehicle with "Kapp Radio, TV Sales Service" painted on the door. A piano sits on the right side of the stage. (Courtesy of the City of Chester.)

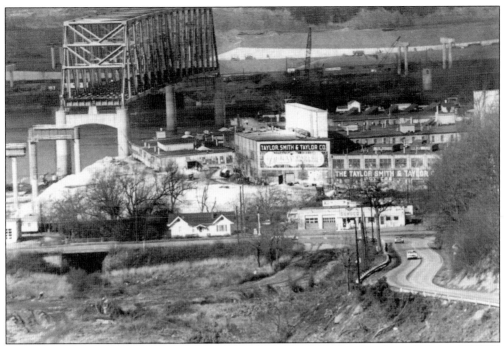

The Jennings Randolph Bridge is being built in the 1970s. Taylor, Smith, and Taylor (TS&T) fills the lots behind Don Chaney's Sunoco station. (Courtesy of the Hancock County Historical Museum.)

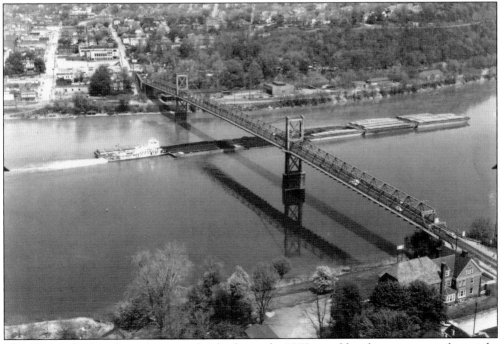

The Chester Bridge, shown here on a bright day in the 1960s, could no longer support the weight of modern traffic. At that time, vehicle heights were restricted by the overhead bar on each side of the bridge. (Courtesy of the Arner Funeral Chapel.)

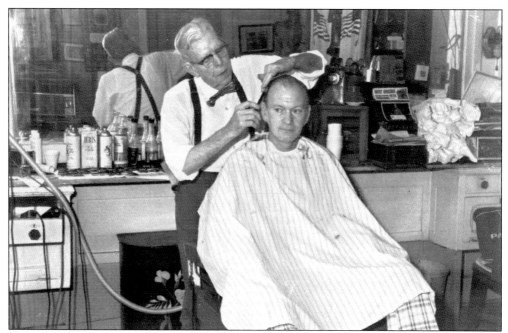

Barber Paul Johnston, born in Chester in 1907, graduated from Chester High School in 1925 before attending the Pittsburgh School of Barbering. He opened his own shop in Chester in 1928 and took two years off to serve in the army during World War II. According to Roy Cashdollar, Johnston's shop was "the favorite meeting place for the boys, with many decisions being made here." (Courtesy of the Hancock County Historical Museum.)

The Harker Pottery Company moved to Chester in 1930 and employed about 350. The company sold out to the Jeanette Glass Company in 1969, and Ohio Valley Stoneware, Inc., purchased it in 1974. A fire on September 17, 1975, gutted the building. The only pottery left in Hancock County today is the Homer Laughlin China Company. (Courtesy of the Arner Funeral Chapel.)

Four

NEWELL

Once East Liverpool's pottery owners had successfully expanded their industry to Chester, they turned to another plot of land a few miles downriver. W. E. Wells, Louis and Marcus Aaron, Edwin Knowles, and a handful of other investors created the North American Manufacturing Company and several subsidiaries, including the Newell Bridge Company, the Newell Construction Company, and the Newell Street Railway Company, for the purpose of expanding their operations to the newly platted town of Newell. The company purchased land from W. F. Lloyd of Pittsburgh, which included the old Newell farm, giving the new town its name. The Newell Bridge was completed in 1905, and both the Edwin M. Knowles Company and the Homer Laughlin China Company built potteries in Newell. Homer Laughlin's Plant No. 4 was heralded as the largest pottery in the world, designed to employ 1,200.

The town of Newell grew up around the potteries, and other local industries included Globe Brick Company, Metsch Refractories Company, and the Kenilworth Tile Company. In December 1907, there were 130 houses and a population of 700. By the end of the 1920s, Newell had a post office, an automobile service station, a drugstore, a hardware store, a butcher shop, a lumber company, a newsstand, a variety store, and half a dozen or more groceries. The town did not incorporate, and by 1923, its population had leveled off at 1,800, as it would remain for decades.

This is the location for the town of Newell, surveyed in preparation for the construction of the bridge, potteries, and potters' houses. (Courtesy of the Arner Funeral Chapel.)

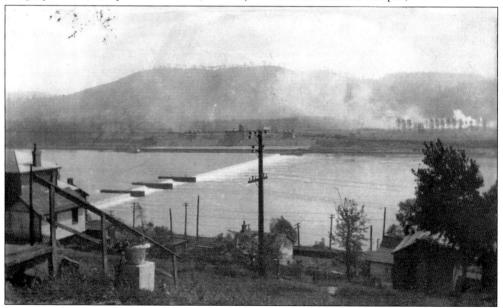

This vantage is from Ohio looking across the river toward the present Kennedy Marina. The wall on the far side, which still exists, likely was part of the lock system. (Courtesy of the Hancock County Historical Museum.)

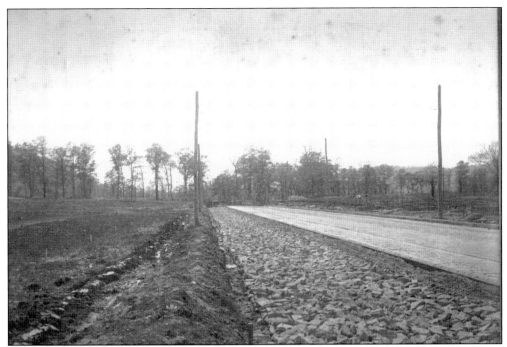

This photograph appears to be of the newly constructed road beside which the Homer Laughlin Plant No. 4 would be built. The company purchased the lots in 1905. (Courtesy of the Homer Laughlin China Company.)

This image shows the construction of the Newell Bridge in progress. On July 4, 1905, when the bridge was completed, W. E. Wells and Edwin M. Knowles rode in an automobile leading over 1,000 people across it. (Courtesy of the Homer Laughlin China Company.)

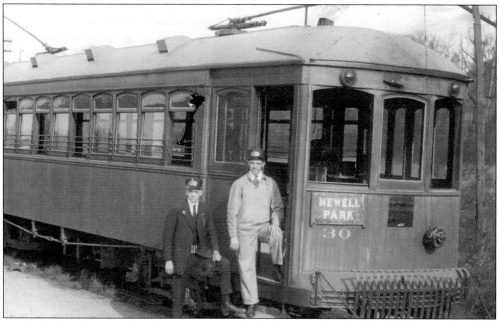

Ten days after the Newell Bridge was completed, the Newell streetcar line opened and began to shuttle people from East Liverpool to Newell and back again. Many potters kept their residence in East Liverpool and commuted to Newell on the streetcar. Pictured is the Newell Park Streetcar. (Courtesy of the Hancock County Historical Museum.)

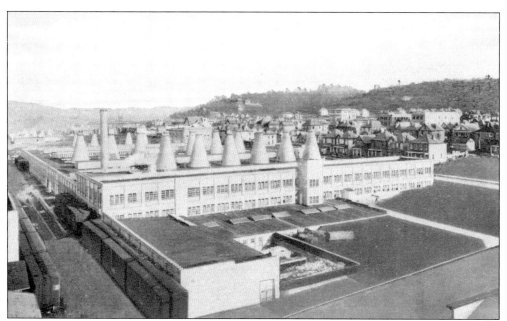

Seen is the Edwin M. Knowles pottery in Newell. Knowles was one of several investors in the Newell Bridge. The Knowles company had also built a pottery in Chester in 1900, which employed 187 in 1926. Louis and Marcus Aaron invested in the Knowles pottery as well as Homer Laughlin. (Courtesy of Krista S. Martin.)

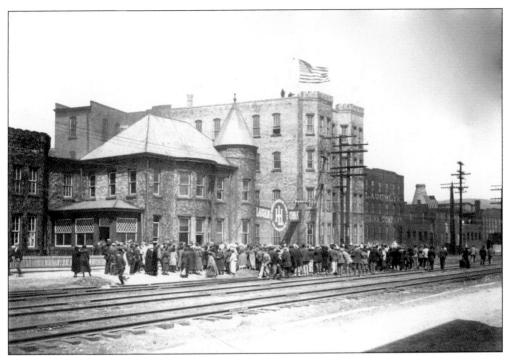

A crowd gathers at Homer Laughlin for a flag raising in the early part of the 20th century. Flag raisings were a popular way to display patriotism during World War I. (Courtesy of the Homer Laughlin China Company.)

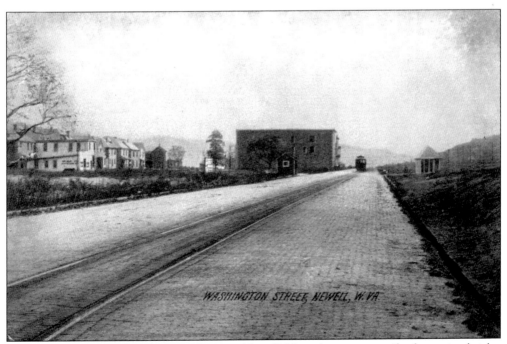

This is an early view of Washington Street in Newell. Note the streetcar rails, the paving bricks, and the streetcar in the distance. (Courtesy of the Arner Funeral Chapel.)

Here is a postcard panorama of the "South Front of Plant No. 4, the Homer Laughlin China Company, Newell, W. Va.," heralded as the largest pottery in the world. Homer and Shakespeare Laughlin started the company in East Liverpool, Ohio, in 1873. Homer Laughlin and his bookkeeper, W. E. Wells, incorporated in 1896. Marcus and Louis Aaron bought out Laughlin, and while the Homer Laughlin name remained, Homer Laughlin the man gradually withdrew

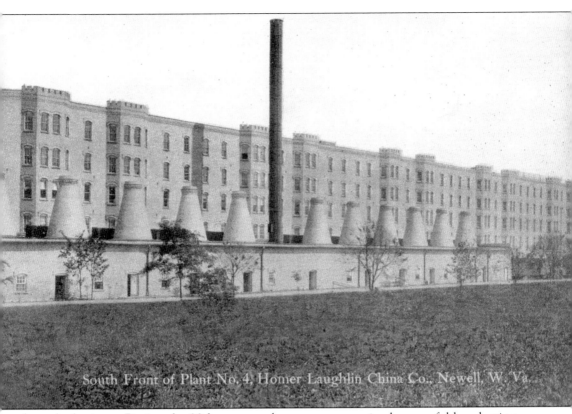

South Front of Plant No. 4, Homer Laughlin China Co., Newell, W. Va.

from the business. During the 20th century, the company remained successful by adapting their product lines to the ever-changing tastes and fashions of their consumers. In recent years, Homer Laughlin's Fiesta dinnerware has been the company's most popular line. (Courtesy of the Homer Laughlin China Company.)

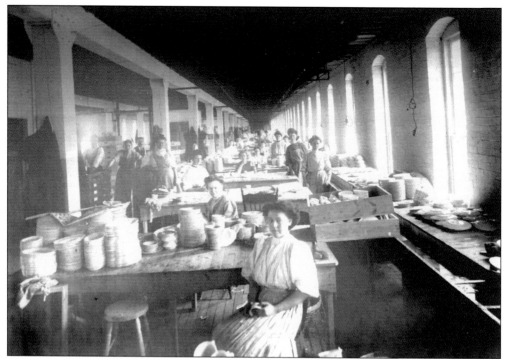

Taken in 1908, this photograph shows the Homer Laughlin decorating room. As applying decals to dinnerware became more popular, potteries hired large numbers of "decal girls" to do the work. (Courtesy of the Homer Laughlin China Company.)

Pictured is the main office of the Homer Laughlin China Company. (Courtesy of the Homer Laughlin China Company.)

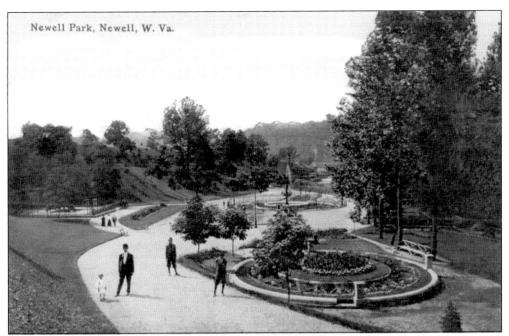

Newell Park, Newell, W. Va.

The Newell Park in the early 1900s featured flower beds, fountains, a duck pond, and a seal pen, and the fenced-in area on the far left held polar bears at one time. (Courtesy of Krista S. Martin.)

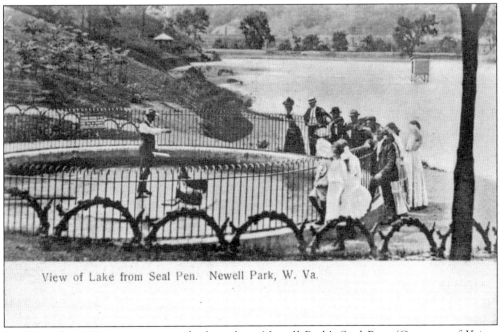

View of Lake from Seal Pen. Newell Park, W. Va.

In this early-1900s image, a man feeds seals in Newell Park's Seal Pen. (Courtesy of Krista S. Martin.)

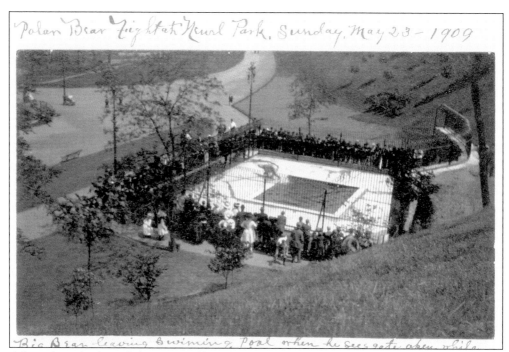

Polar Bear Fight at Newl Park, Sunday, May 23 - 1909

Big Bear leaving Swiming Pool when he sees gate open while

A horrific polar bear fight at Newell Park attracted a crowd on Sunday, May 23, 1909. The handwritten caption on the photograph reads: "Big bear leaving swimming pool when he sees gate open while dead body of little bear is being dragged out. He made a [break?] for the open gate, which clangs shut in his face." (Courtesy of Robert Wells.)

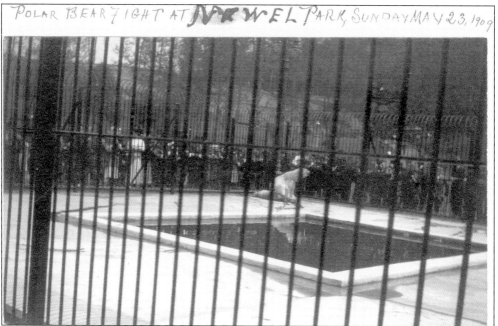

POLAR BEAR FIGHT AT NEWEL PARK, SUNDAY MAY 23, 1909

The caption on this photograph of the 1909 polar bear fight at Newell Park reads: "Big bear wailing over dead body of his victim. A remarkable illustration of remorse." (Courtesy of Robert Wells.)

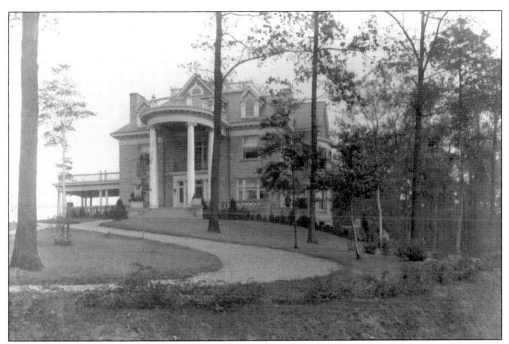

W. E. Wells had this house built in 1909 on Virginia Terrace, on the heights above Newell. (Courtesy of Robert Wells.)

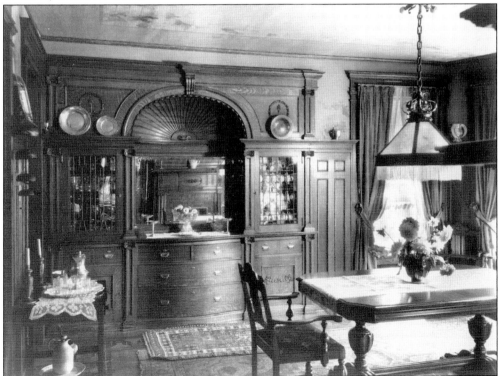

This 1911 photograph shows the dining room inside the Wells house. Note the magnificent sideboard with the traditional shell carving above the mirror. (Courtesy of Robert Wells.)

W. Edwin Wells poses in front of a bottle kiln. In addition to being part-owner of Homer Laughlin, Wells served as president of the United States Potters Association (USPA) in 1905 and 1906 and served as chair of the USPA labor committee until 1928. (Courtesy of the Hancock County Historical Museum.)

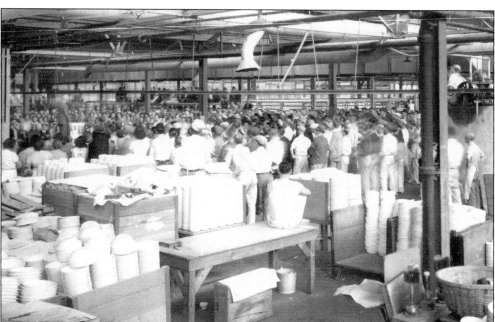

Joseph M. Wells addresses the potters of Homer Laughlin on October 23, 1936. In 1928, Wells served as president of the USPA and took over his father's chair of the USPA labor committee. (Courtesy of the Hancock County Historical Museum.)

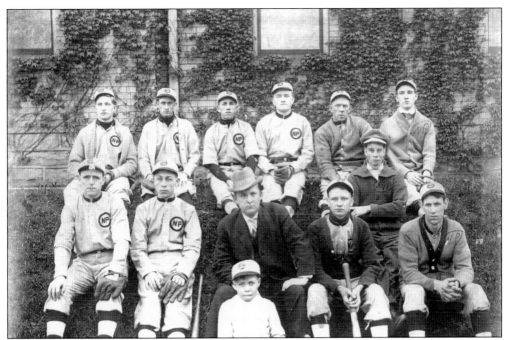

Pictured is the Newell Presbyterian Church baseball team in 1913. (Courtesy of the Hancock County Historical Museum.)

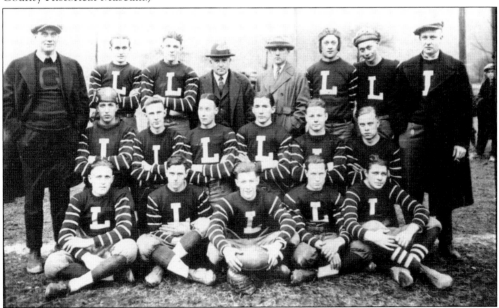

The Homer Laughlin No. 5 football team was the undefeated champion of West Virginia in 1923. Pictured from left to right are (first row) Crubaugh, guard; Shilling, guard; Watters, captain and quarterback; Baker, guard; and Shively, left guard; (second row) H. Dickey, left tackle; Laughlin, right end; Salisbury, right end; Hooven, right half; Boso, left half; and Foultz, right guard; (third row) McCoy, assistant manager; Silliman, center; Parsons, fullback; Ed Wells Jr., coach; Schaffer, coach; Copestick, left end; Cosgrove, right tackle; and Mowery, manager. (Courtesy of the Hancock County Historical Museum.)

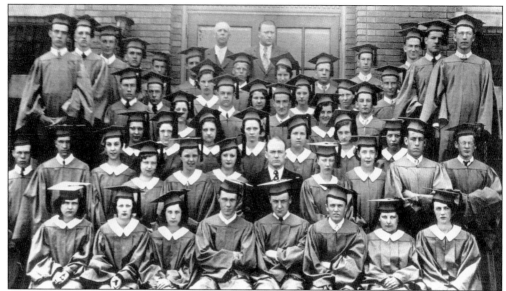

The Wells High class of 1933, as written on the back of the photograph, includes the following, from left to right: (first row) Ursla Stopper, Mary Graham, Oma Burch, Harry Mosser, Richard Hocking, Chuck Bennett, Violet Sayers, and Ruth Wells; (second row) two unidentified, Jane Graham, Dorothy Daugherty, unidentified, Marie Bennett, Mr. Miller (teacher), Helen Bosser, Helen McKenna, Richard Huffman, and Bill Porter; (third row) Gladys Andrews, Edith Swan, Dorothy Porter, Jane Ferguson, Mary Talbot, Thelma Swifth, and Lucille Young; (fourth row) Burt Kaufmann, Ernie Thornberry, Marcella Simpson, Willard Enochs, unidentified, Tom Nathaniel, Milford Derda, and unidentified; (fifth row) Trenton McCoy, two unidentified, ? McSwegin, Mary Newlin, unidentified, Norman Gregory, and Harold Dickey; (sixth row) Libby Stephen, H. D. Osborn, ? Rail, Mr. Evarts, Mr. Walters, Ms. Snowden, unidentified, and Winzell Campbell. (Courtesy of the Hancock County Historical Museum.)

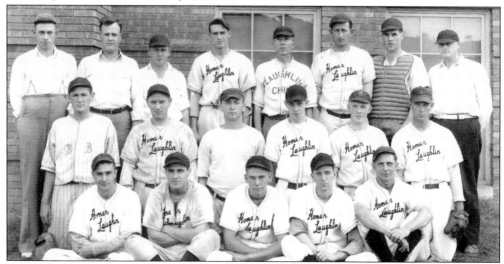

This 1936 photograph is of the Homer Laughlin China baseball team. The handwritten caption reads, "Columbiana County League Champs." Columbiana County is across the river, where East Liverpool, Ohio, is located. Many companies in the 1920s and 1930s sponsored sports teams to help promote company loyalty. (Courtesy of the Hancock County Historical Museum.)

Pictured are the charter members of the Stooge's Club, an association of the foremen and salespeople of Homer Laughlin. Walter Emerson, in the first row on the far left, became head of the company's newly created engineering department in 1934. The Massachusetts Institute of Technology (MIT) graduate automated several of the pottery's processes before dying of a heart attack at an early age in 1947. (Courtesy of the Hancock County Historical Museum.)

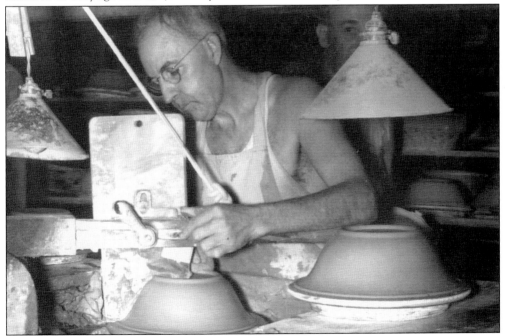

A jiggerman at Homer Laughlin uses a water tool to form the ware from clay. This method of production dates back to 19th-century Staffordshire, England, and was not eliminated until the second half of the 20th century. (Courtesy of the Homer Laughlin China Company.)

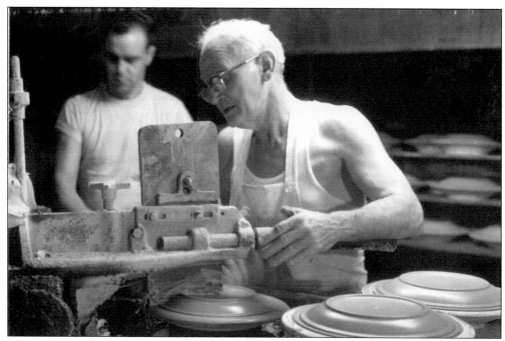

The jiggerman relied on two helpers. The batterout would throw the clay down to get the air out, and the moldrunner would carry away full molds and bring back empty ones. Often the jiggerman would hire family members to do these jobs. (Courtesy of the Homer Laughlin China Company.)

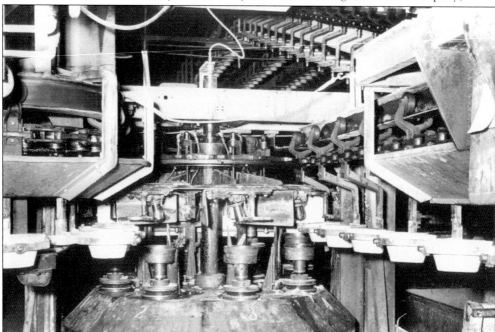

This cup automatic or cup jigger at Homer Laughlin formed cups out of clay. It has long been out of use. In 1940, Homer Laughlin's head of engineering, Walter Emerson, patented an automatic jigger that made plates, which he nicknamed "King Kong." These machines slowly displaced the jiggermen. (Courtesy of the Homer Laughlin China Company.)

This holloware caster is pouring slip, or liquid clay, into plaster molds. After the clay gels up to form the walls of the ware, they dump out the excess clay and allow it to finish drying in the mold. This process is often used for complex shapes. (Courtesy of the Homer Laughlin China Company.)

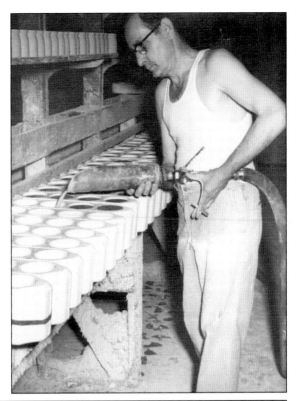

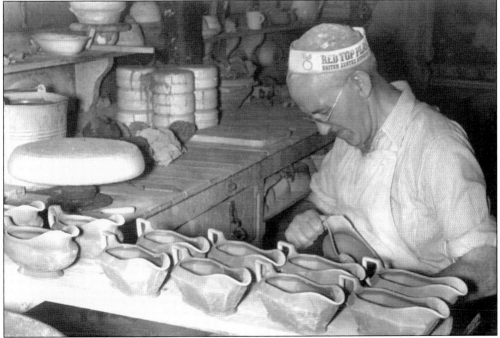

Finishers use a tool that looks like a paring knife to remove rough edges and excess clay or "flash." Each finisher bends the blade to suit their style. (Courtesy of the Homer Laughlin China Company.)

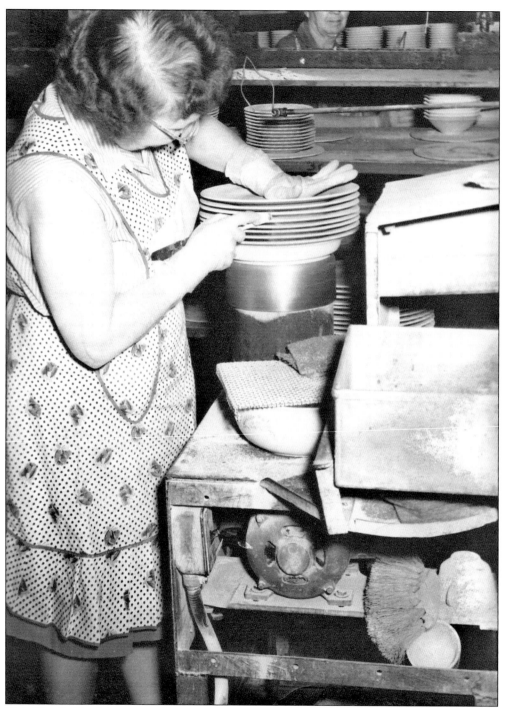

This "flat finisher" is so named because she is smoothing the edges of flatware. While potteries like Homer Laughlin automated many processes during the 20th century, the need for human hands to perform delicate work has never been eliminated, especially in processes like finishing. (Courtesy of the Homer Laughlin China Company.)

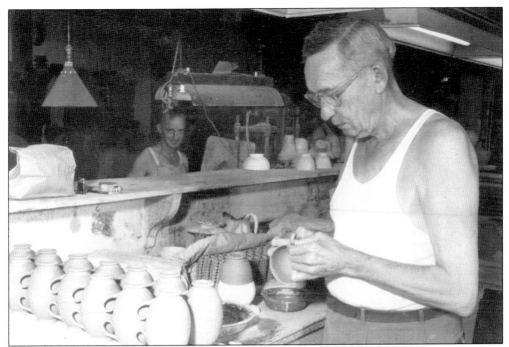

This man is applying handles to cups at Homer Laughlin. (Courtesy of the Homer Laughlin China Company.)

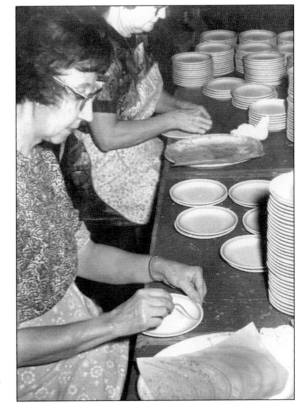

Putting decals on ware takes precision. At one time, they put the decals on bisque ware, which is fired but not glazed. The paint would absorb into the ware, which meant that the decaler had only one chance to get it right. (Courtesy of the Homer Laughlin China Company.)

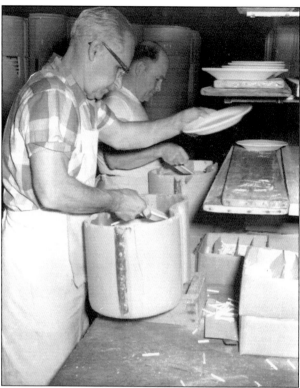

The ware is "pinned" into saggars before putting them into the kilns. Wooden pins are used to keep the ware separated so that air can flow between them. (Courtesy of the Homer Laughlin China Company.)

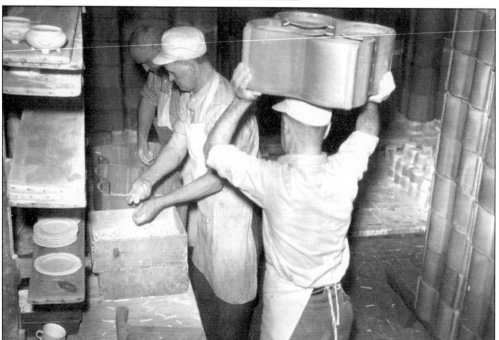

Kiln placers and drawers load and unload ware from the saggars. Note the box of wooden pins on the table that are used to keep the ware separated in the saggars. (Courtesy of the Homer Laughlin China Company.)

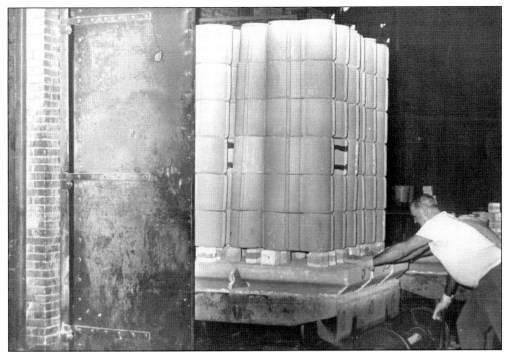

Kiln firemen push a kiln car full of saggars into a tunnel kiln at Homer Laughlin. (Courtesy of the Homer Laughlin China Company.)

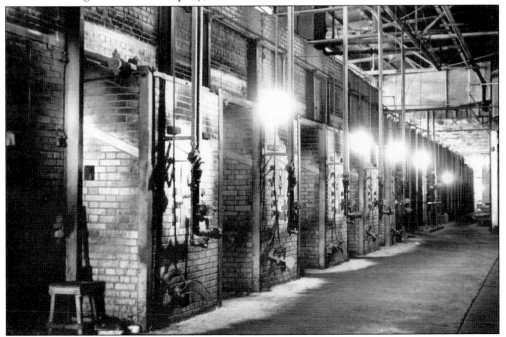

Tunnel kilns replaced the bottle kilns in the 1920s and 1930s. When Homer Laughlin built Plant No. 6, they equipped it with the latest technology, including tunnel kilns. The tunnel kilns of those days had about a 24-hour cycle to fire and cool the ware. Within a decade, the company relied solely on tunnel kilns. (Courtesy of the Homer Laughlin China Company.)

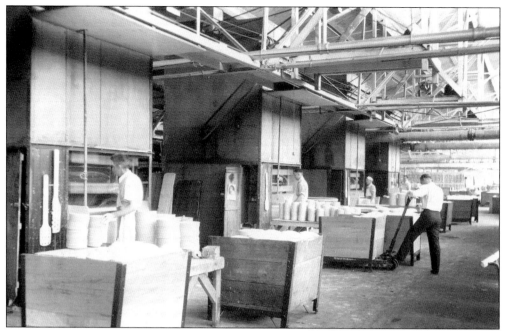

These employees work in front of the dryers at Plant No. 6 at Homer Laughlin in 1931. The men are probably dipping bisque ware into glaze—note the white color of the nearest worker's hand. While the glaze is now sprayed onto the ware, the workers are still called "dippers." (Courtesy of the Hancock County Historical Museum.)

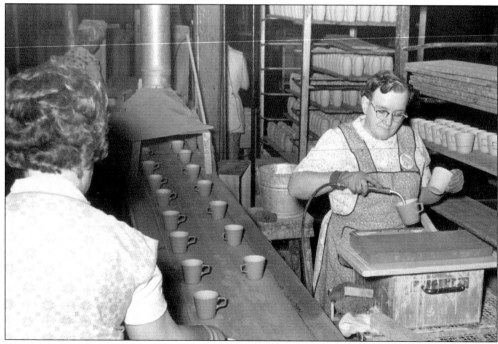

These women appear to be using a vacuum device to dip cups in a colorant. The engobe process is the use of a clay-based colorant on bisque ware. The cup is dipped down to the point just before the colorant spills over the brim. (Courtesy of the Homer Laughlin China Company.)

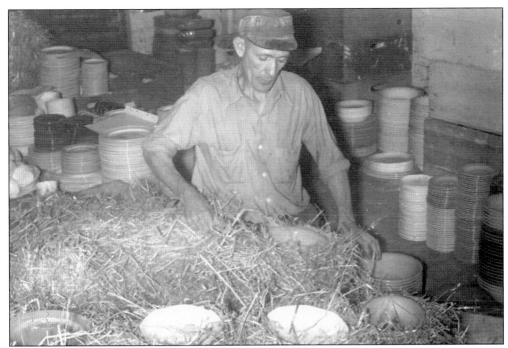

These employees pack ware into barrels with straw. This photograph was taken in 1962, but this was the method of packing from the early days of the company until the 1960s. (Courtesy of the Homer Laughlin China Company.)

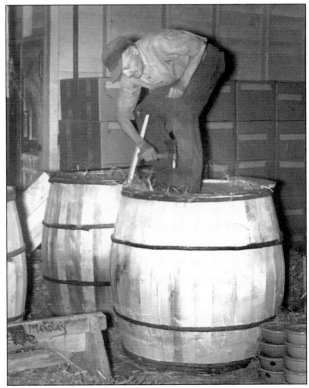

Local lore holds that many of the people who built these barrels and packed the ware in them came from southern West Virginia. Since part of that process required hammering the barrel hoops into place, these workers and other southern West Virginians in the county became known as "hoopies." (Courtesy of the Homer Laughlin China Company.)

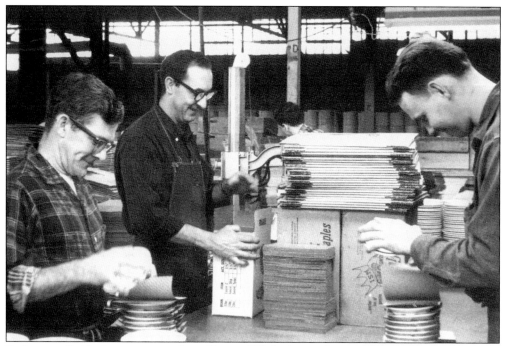

Packers put finished ware into cardboard boxes. While they no longer used straw by this time, the pieces of perforated cardboard were and still are called "straw." (Courtesy of the Homer Laughlin China Company.)

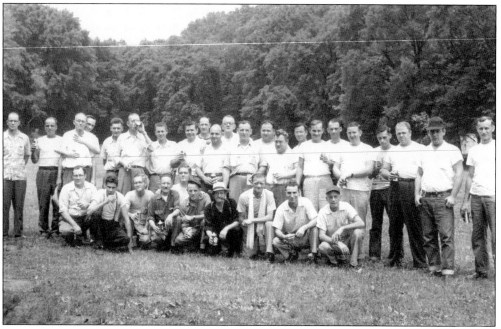

Companies saw company picnics, like company sports teams earlier in the 20th century, as an important way to build company loyalty and retain employees. These Homer Laughlin warehousemen enjoy an outing at Tomlinson Run State Park in 1960. (Courtesy of the Hancock County Historical Museum.)

Five

WEIRTON

Cyrus Ferguson spent most of his life working on farms in Hancock County until 1883, when he opened a meat market in Wellsburg, West Virginia. After investing in a brick factory and oil wells, Ferguson purchased 10 farms near Hollidays Cove totaling 1,700 acres in 1902 and laid out lots for a town. In 1909, he sold 1,200 acres to Ernest T. Weir, who was looking to expand his tin plate company. The new mill was built in the north end of Hollidays Cove and went into production by December of that year.

The first houses of the self-proclaimed new town of Weirton were built on a hillside overlooking the mill, and the population swelled as tin plate rollers and heaters from around the country arrived. The company incorporated as Weirton Steel in 1918 and the following year began expanding its operations to include basic steel production. Weirton's population grew rapidly to 8,000 by 1920 and to 18,000 by 1940. Residents of some 47 different countries lived in Weirton by the beginning of World War II, with Italians, Greeks, and Poles being the most numerous. African Americans from the South also made their way to the steel town, numbering over 1,000 by 1930.

In 1947, Weirton, Weirton Heights, Marland Heights, and Hollidays Cove combined to form the newly incorporated city of Weirton, whose population topped 24,000 in 1950. Weirton in the 1950s was known for its booming shopping district, patriotic parades, and high school sports. While the population declined toward the end of the 20th century, Weirton's diversity, festivals, and sports still remain central parts of community life.

The New Cumberland Junction in Hollidays Cove dates back to 1887, when Capt. John Porter of New Cumberland canvassed the farmers of Hollidays Cove, including William Lee, Mary Crawford, and Tallman Hooker, to acquire the right-of-way for a new branch of the railroad. This was the point in Hollidays Cove where the railroad turned north and connected New Cumberland's 18 brickyards to the rail system. Dennis Jones is currently researching the junction and provided this information. (Courtesy of Dennis Jones.)

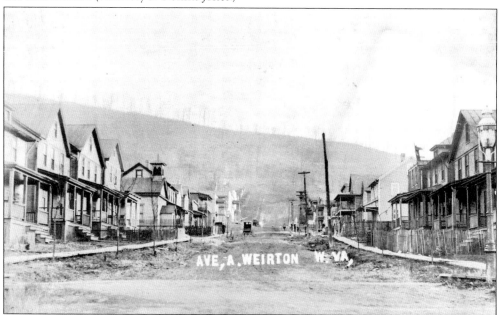

These houses on Avenue A in the north end of downtown Weirton c. 1910 were among the first built in Weirton. The new town of Weirton was actually located in Hollidays Cove, whose residents incorporated in 1912, concerned that their town would be overtaken by Weirton. Note the gas lamp in the foreground at the right side of the photograph. At the top of the hill is present-day County Road or State Route 2. (Courtesy of Dennis Jones.)

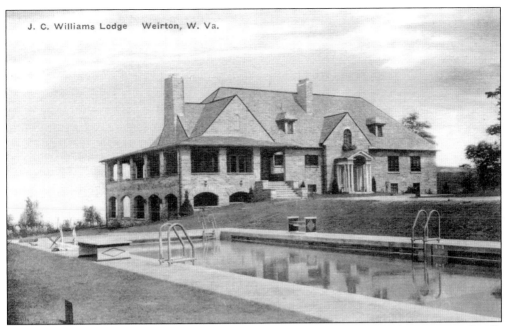

This postcard shows the J. C. Williams Lodge. John C. Williams served as Weirton Steel's second president from 1929 until he died suddenly on June 1, 1936, at the lodge of the Williams Country Club that was named for him. Born in Wales in 1876, like so many of his countrymen, he immigrated to the United States during the tin plate boom. He worked with E. T. Weir at the Monessen plant of the American Tin Plate Company and left with him in 1905 to work at Phillips Sheet and Tin Plate Company. (Courtesy of Krista S. Martin.)

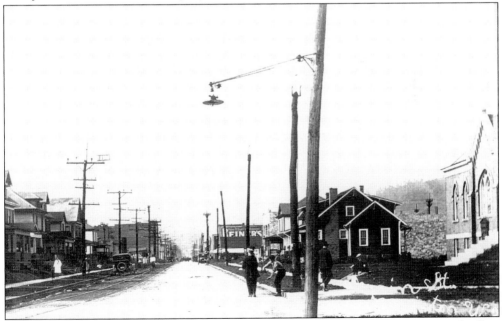

Pictured is the intersection of Main Street and Lee Avenue in the early 1900s. Note the First Christian Church on right, which was torn down and rebuilt in the 1950s. (Courtesy of the Top Dog Restaurant.)

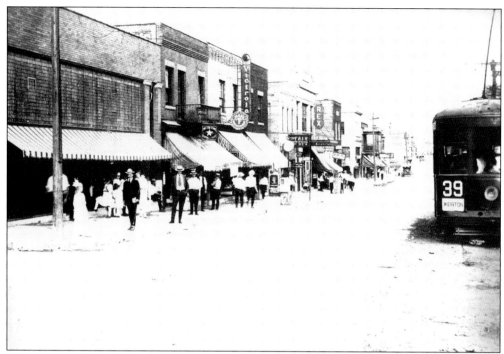

This picture of North Weirton shows the town's two movie theaters, the Victoria and the Rex. Movie theaters became common features of small towns and large cities in the 1920s. (Courtesy of the Top Dog Restaurant.)

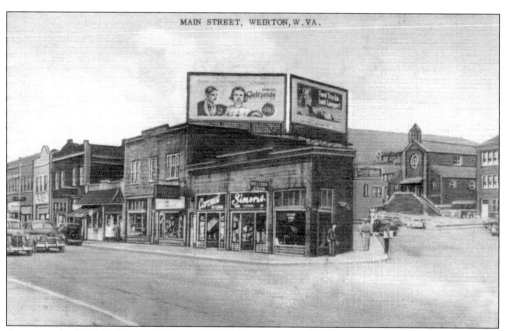

A postcard of "Main Street, Weirton, W. Va." appears to show the intersection of Main Street and County Road in the 1940s. If so, the end of Pennsylvania Avenue would be to the right. (Courtesy of Krista S. Martin.)

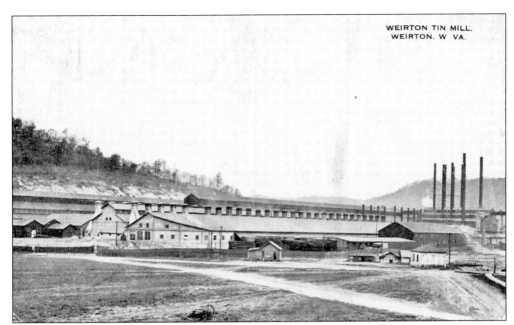

The "Weirton Tin Mill," as its called in this postcard c. 1910, began production in 1909 as part of the Phillips Sheet and Tin Plate Company, named for J. R. Phillips, the then-deceased business partner of Ernest T. Weir. Weir and his associates expanded the mill tremendously after 1918 by adding basic steel production departments, including blast furnaces, open hearths, and Bessemer converters. (Courtesy of Dennis Jones.)

Thomas C. Milsop was 37 years old when he became president of Weirton Steel, the youngest head of a major steel producer. He was born in Sharon, Pennsylvania, in 1898 and worked in several departments of Carnegie Steel before joining the sales department of Weirton Steel. Milsop was the company's third president after E. T. Weir and John C. Williams and was also elected the town's first mayor in 1947. (Courtesy of Victor Greco and Edmund DiBacco.)

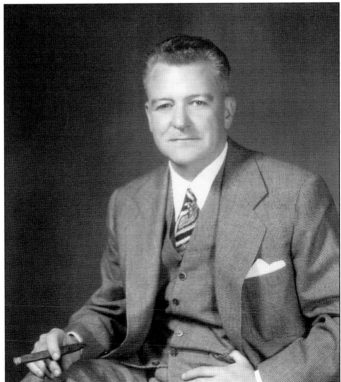

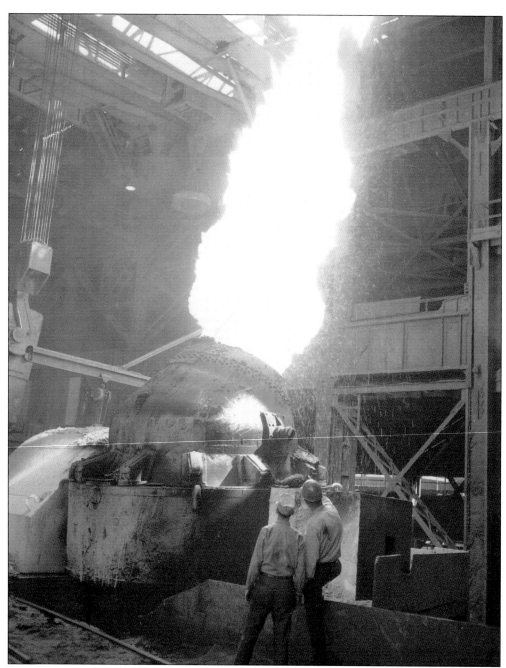

Pictured is a Bessemer blowing at Weirton Steel in the 1950s or 1960s. The Bessemer process was developed in the late 1870s and revolutionized steel production. Previously iron had been made by hand in very small quantities by highly skilled "boilers" or "puddlers." The Bessemer process made more uniform steel and allowed for much greater mechanization. (Courtesy of Victor Greco and Edmund DiBacco.)

Open hearth furnaces replaced many Bessemer furnaces in the early 20th century because they allowed for greater volumes of steel to be produced at once. Weirton Steel installed its first seven 100-ton open-hearth furnaces in 1920. (Courtesy of Victor Greco and Edmund DiBacco.)

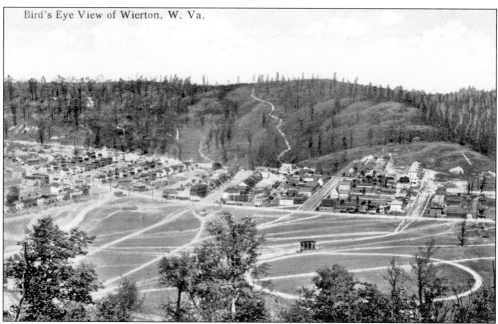

This postcard of the north end of downtown Weirton was taken around 1915 from Marland Heights. Within a few years, the mill expanded into the area where the ball field and the track are shown in the foreground. (Courtesy of Dennis Jones.)

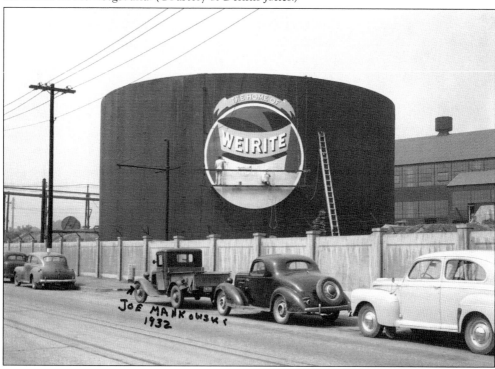

In this 1930s image, a storage tank in Weirton is being painted with the "Weirite" logo, which was simply a brand name for the thin-gauge steel rolled at the plant. (Courtesy of Victor Greco and Edmund DiBacco.)

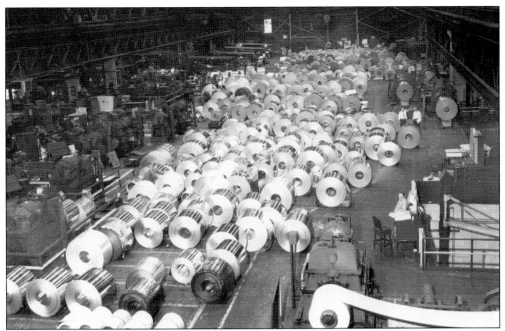

Pictured is the coil floor at Weirton Steel. Prior to 1927, tin plate could only be produced in small squares by very skilled rollers and heaters. Weirton Steel was among the first to invest in the continuous rolling process that produced these coils rather than the rectangular sheets. (Courtesy of Victor Greco and Edmund DiBacco.)

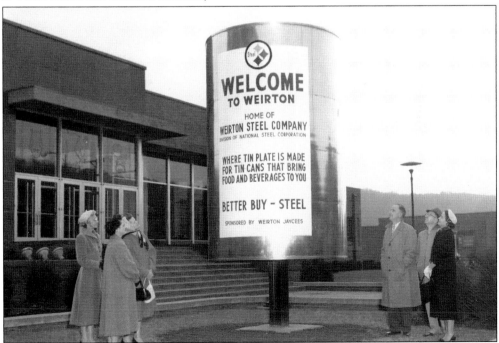

The "Welcome to Weirton" steel can sits in front of the Milsop Community Center. At one time, Weirton Steel was said to produce the metal for one out of every four cans in the United States. (Courtesy of Victor Greco and Edmund DiBacco.)

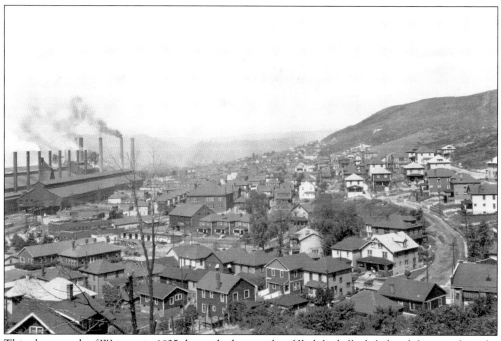

This photograph of Weirton in 1935 shows the houses that filled the hillside behind the open hearths of Weirton Steel. This neighborhood along Weir Avenue was home to a very diverse population that included African Americans, Greeks, Italians, and Poles. (Courtesy of Dennis Jones.)

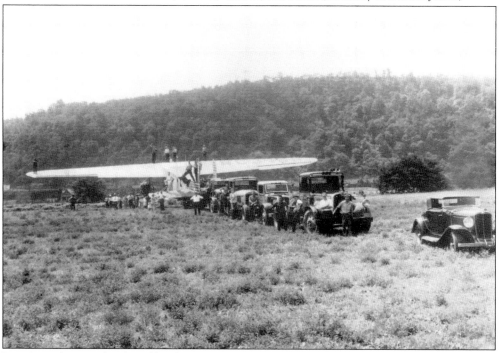

In 1930, a plane made a forced landing on a field near the Steubenville Bridge. Weir-Cove Moving and Storage trucks hauled the plane to the highway, where it was disassembled. The automobile at the front of the line is an Auburn. (Courtesy of Caroline Castelli Herron.)

The caption translates to "Fourth Annual Picnic of the Paleo Fokiano Society 'The Hope' August 18th 1935 at Kings Creek in Weirton, West Virginia." These are the survivors of the Turkish massacres of Christians from Palea Fokea, Asia Minor (present-day Turkey) and their descendants. The original society was founded in Sabraton, West Virginia, in 1910. Members of the society still meet quarterly in Weirton. (Courtesy of Pamela Makricosta.)

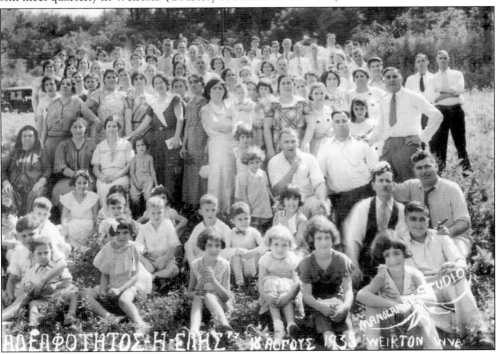

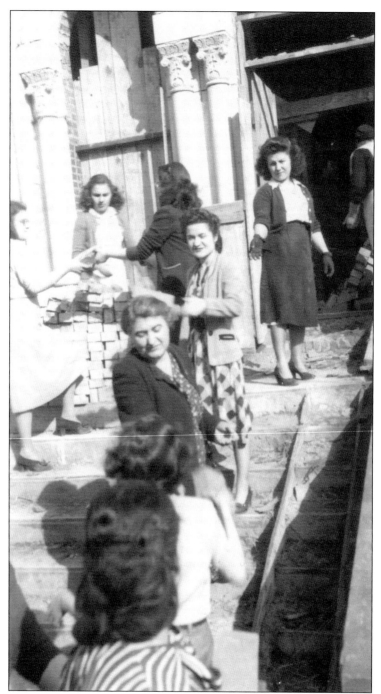

Mothers and daughters of All Saints Greek Orthodox Church in Weirton help to build their new parish. When the first All Saints church was outgrown, lots on West Street were purchased in 1945 and construction began in 1947. Men and women sacrificed their leisure time to dig the foundation and carry bricks. Helen Koukoulis Makricosta is pictured in the center. Helen's parents, Charles and Panagiota Koukoulis, were among those who fled Palea Fokea in 1916. (Courtesy of Pamela Makricosta.)

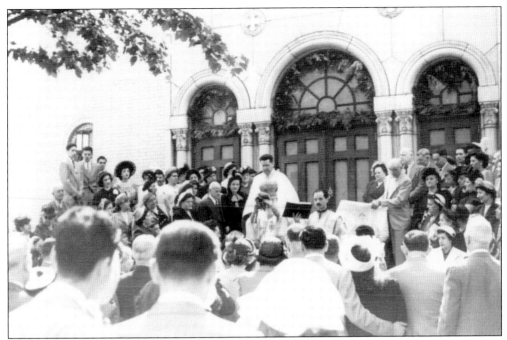

Clergy and laity attend the dedication of the new All Saints Greek Orthodox Church on June 3, 1950. It was "Dedicated to the Glory of God and All His Saints." (Courtesy of Pamela Makricosta.)

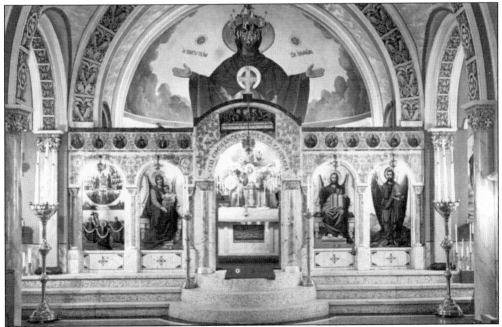

Pictured is the interior of All Saints Greek Orthodox Church in Weirton. The "Iconostasion" separates the Holy Sanctuary from the nave of the church. In 1956, the church hired Constantine Triantafillou, a graduate of the Art School of the Polytechnic of Athens, Greece, to decorate the interior. (Courtesy of Pamela Makricosta.)

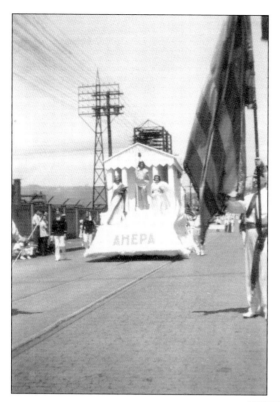

This float was sponsored by the Weirton Chapter of AHEPA, the American Hellenic Educational Progressive Association, c. 1950. Greek Americans in Weirton formed AHEPA Chapter 103 on May 9, 1926. AHEPA is a civic organization originally intended to help Greek immigrants assimilate into American society; its mission now includes philanthropy and education. (Courtesy of Caroline Castelli Herron.)

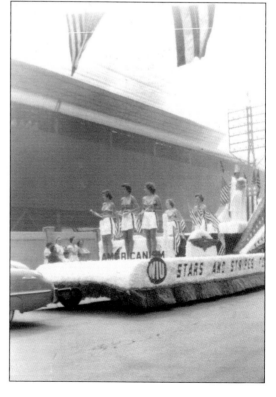

Americanism Week in Weirton in 1950 culminated with a parade on the Fourth of July. The Weirton Independent Union (WIU) sponsored this float at a time when it was at the center of a controversy. Three weeks after this photograph was taken, a U.S. Court of Appeals upheld an earlier decision that the WIU was a company union and must disband. (Courtesy of Caroline Castelli Herron.)

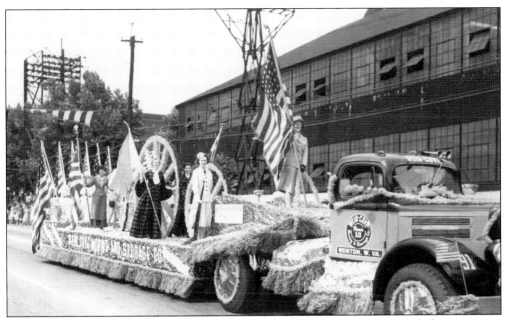

The Weir-Cove Moving and Storage Company in the 1950 Americanism parade features a sign that reads "Flags of Americanism, 1776 to 1950." Americanism Week promoted free enterprise and subtly equated the United Steelworkers of America with socialism. In October 1950, the newly created Independent Steelworkers Union defeated the United Steelworkers two-to-one in a union election. (Courtesy of Caroline Castelli Herron.)

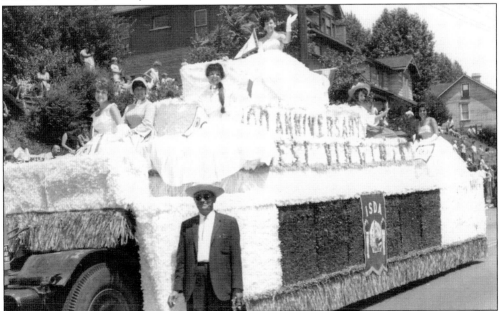

The float of the Weirtonian Lodge of the Italian Sons and Daughters of America in a 1963 parade celebrates the 100th anniversary of West Virginia's statehood. Michael Starvaggi stands in front of the float. Born in Italy in 1895, Starvaggi arrived in Weirton in 1912 and in a short time opened a grocery store. In 1919, he started the Weirton Coal and Ice Company and continued to build his business. At its height, Starvaggi Industries employed 400. (Courtesy of Chester Grossi.)

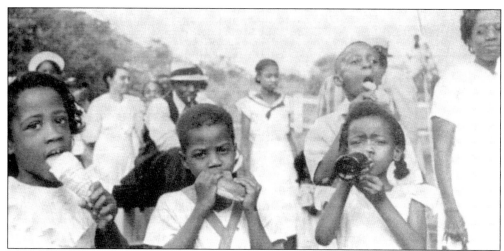

This image is of a Fourth of July celebration at Washington Park in 1937. Over 1,000 African Americans settled in Weirton by the 1930s and were segregated in many ways by the city fathers. While Dunbar School was the most visible symbol of segregation, students fondly remember Dunbar's teachers and their experiences there. Schools in Weirton integrated the year after the *Brown v. Board of Education* decision of 1954. (Courtesy of the Weirton Historic Landmarks Commission.)

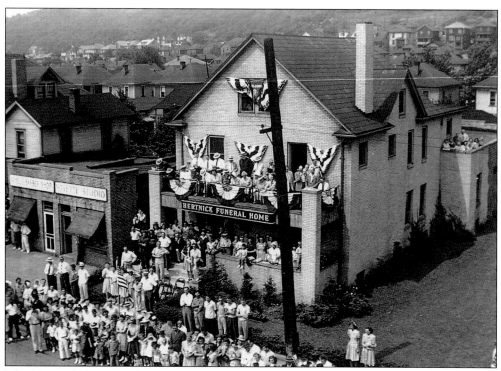

John Hertnick, born in Glen Lyon, Pennsylvania, served in World War I; received his degree in mortuary science in 1921; and came to Weirton in 1922 to open the Hertnick Funeral Home. To the left are Schell's Barber Shop and Movette Studio. This photograph appears to have been taken during one of Weirton's many patriotic celebrations in the 1950s. (Courtesy of Newbrough Photo.)

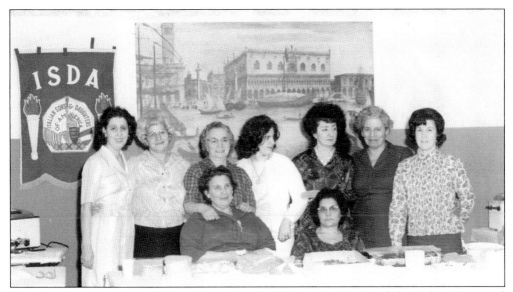

A committee prepares an Italian dinner for the Weirtonian Lodge of the Italian Sons and Daughters of America (ISDA) in the 1960s. The ISDA was started in 1930 to help perpetuate Italian American culture and values through community events. Locally the Weirtonian Lodge also awards a college scholarship every year and brings in speakers for banquets. (Courtesy of Chester Grossi.)

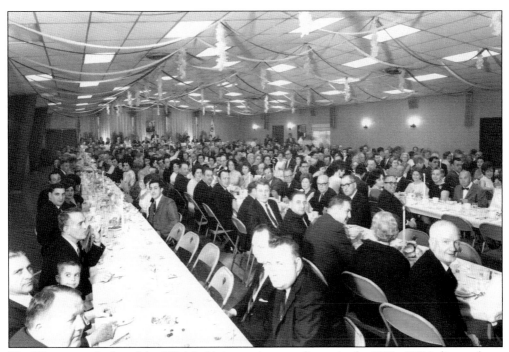

The Weirtonian Lodge of the ISDA holds its anniversary dinner in the 1960s. ISDA dinners have been popular venues for local and national politicians. (Courtesy of Chester Grossi.)

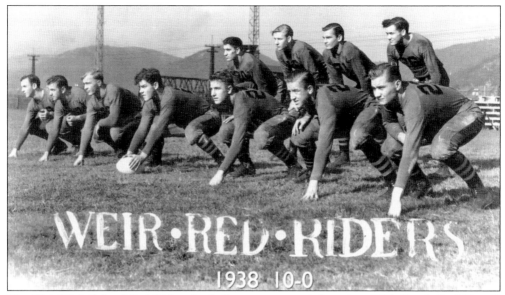

The Weir High School Red Riders football team went undefeated in 1938. Coach Carl Hamill (not pictured here) was the architect of this wildly successful football dynasty. Hamill graduated from Bethany College in 1929 and began coaching at Weir High that fall. Virgil Cantini, who went on to become a well-known sculptor, was a quarterback for the team. (Courtesy of Edmund DiBacco and the People's Choice Café.)

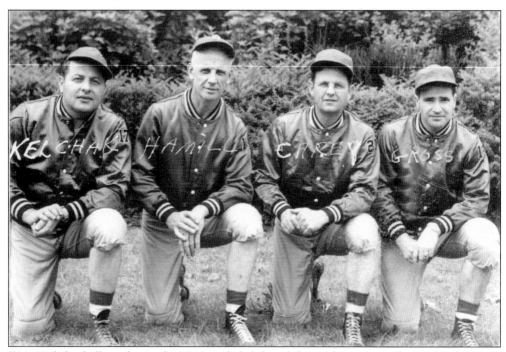

Weir High football coaches in the 1940s included, from left to right, assistant Paul Kelchak, Coach Carl Hamill, assistant James Carey, and assistant Chester Grossi. During the 1940s, the Red Riders were nearly unbeatable. Hamill, who coached from 1929 until 1951, amassed an overall record of 169 wins, 35 losses, and 13 ties. (Courtesy of Edmund DiBacco and the People's Choice Café.)

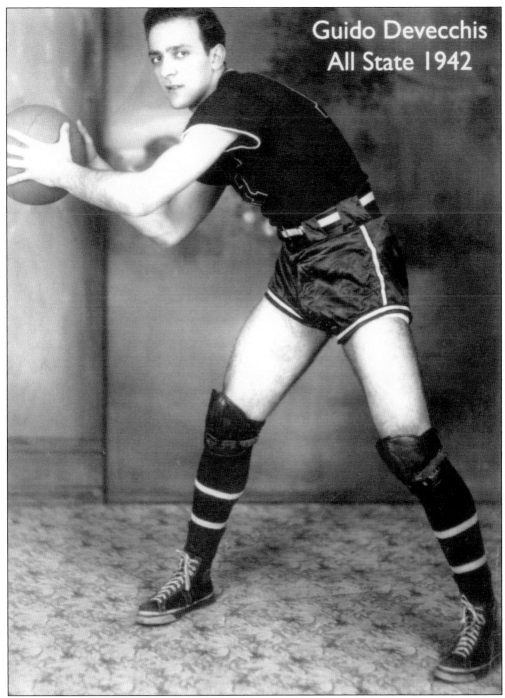

Guido "Weedo" Devecchis poses here in his basketball uniform. He made the All-State basketball team in 1942. Devecchis also quarterbacked the Red Riders to many victories. He went on to letter as a running back on West Virginia University's football team in 1946. (Courtesy of Edmund DiBacco and the People's Choice Café.)

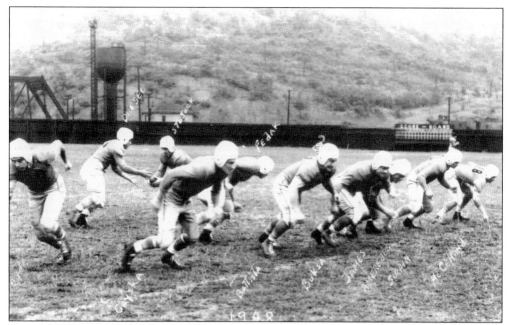

Pictured are members of the 1948 Weir High football team. From left to right are Hayda, Dresel, Stojack, Gryska, Fedak, Battista, Buksa, James, Ameredes, Swain, and McCelland. (Courtesy of Edmund DiBacco and the People's Choice Café.)

Michael Sinicropi, in the dark raincoat on the left, poses with the 1962 Madonna Blue Dons football team that went on to become AA Champs of the Ohio Valley Athletic Conference that year. Included in this picture are Bill Vagnoni (at left wearing hat), John Backel (#45), Joe Richards (dark raincoat holding trophy), Gene Trosch (above trophy), Bob Canai (holding trophy), Stan Zgurski (#30), Bill Zanieski (#43), Paul Altomare (#50, far left), Larry Prybyz (above Altomare), and Ted Gill (kneeling in front of trophy). (Courtesy of Chester Grossi.)

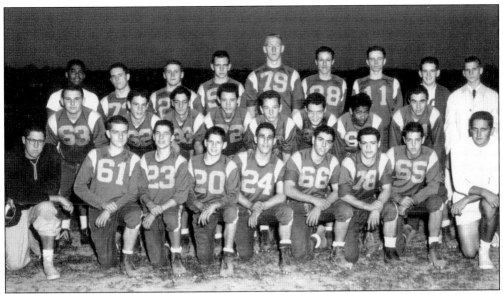

The Madonna High School football team, c. 1961–1962, included, from left to right, (first row) Joe Krivak, Mike Ivaun, Rich Mahoney, Joe Tokash, George Gurrera, Paul Altomare, Tony DiGeramo, Joe Stetar, and Coach Woody Miller; (second row) Jim Pauchnik, John Panconi, John Castelli, Bob Kolonic, Larry Pryzbyz, unidentified, Mike Compos, and John Pete; (third row) Grant Salter, unidentified, Bob Canai, Bob Maslowski, Gene Trosch, John Backel, Bill Zanieski, unidentified, and Dave Weiss. Bob Barnett remembered when his Newell Vikings got shellacked by Madonna in 1958 that the "open hearth was going full blast, the game seemed endless." (Courtesy of Edmund DiBacco and the People's Choice Café.)

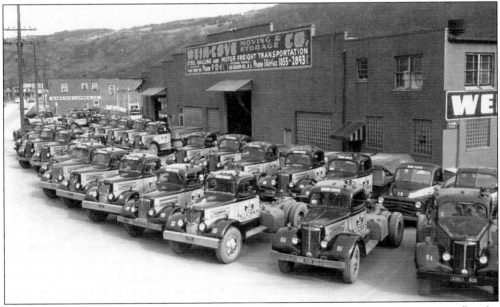

Romano "Romie" Castelli's Weir-Cove Moving and Storage had amassed an impressive fleet by the 1950s. Born in Italy in 1892, he started his hauling business in Weirton in 1916 with one truck. By the 1960s, he had over 125 employees and some 200 trucks, tractors, and trailers. (Courtesy of Caroline Castelli Herron.)

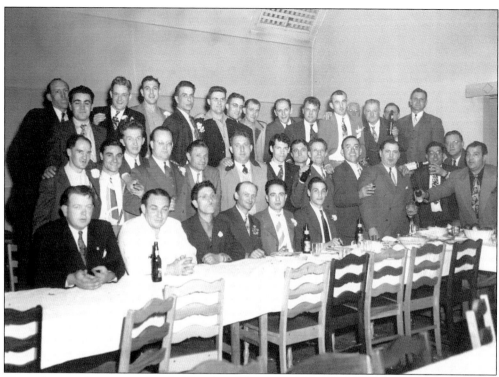

These photographs appear to be of a Weir-Cove Moving and Storage truck drivers' annual party from the 1940s. Below drivers horse around and drink beer. (Courtesy of Caroline Castelli Herron.)

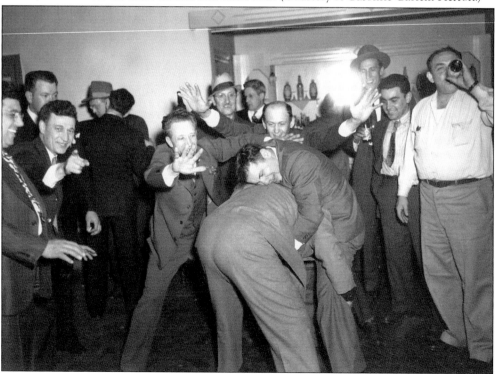

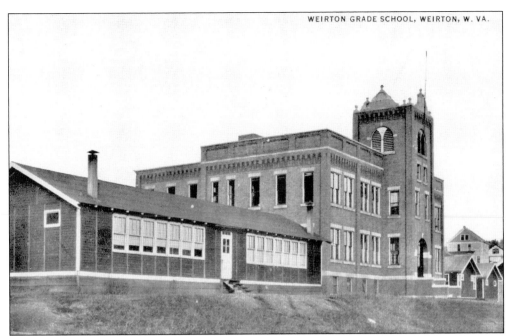

Weirton Grade School was built in 1913 along County Road between Avenues E and F. The so-called "chicken coops" on each side of the school were added in the 1920s because of the tremendous growth in the number of students at the school. (Courtesy of Dennis Jones.)

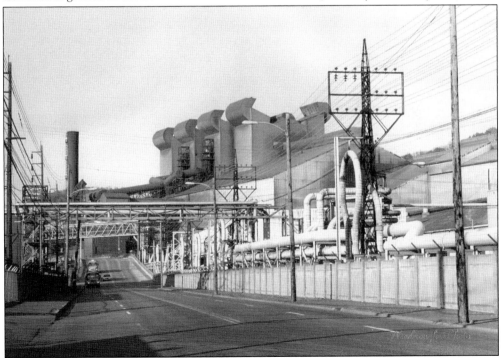

The Basic Oxygen Plant (BOP) began operations in 1967 and was hailed as the "steel mill of the future" for its use of the latest steel producing technologies, including basic oxygen furnaces and continuous casting. (Courtesy of Newbrough Photo and the Hancock County Commissioners.)

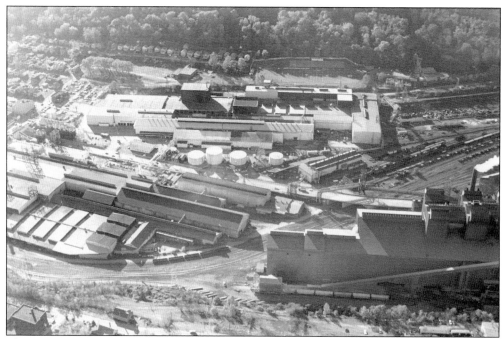

This is an aerial view of the Hot Mill, the Sheet Mill, and the BOP. Weir High Stadium is visible at the top of the photograph. (Courtesy of Newbrough Photo and the Hancock County Commissioners.)

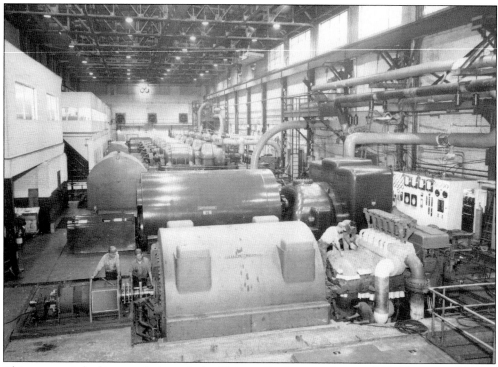

This vantage is looking south through the Weirton Steel power plant in 1957. (Courtesy of Victor Greco and Edmund DiBacco.)

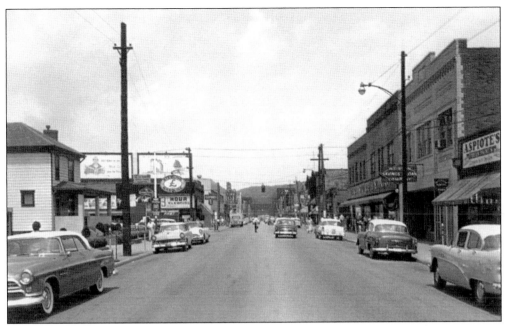

This is a postcard of Main Street, Weirton, in the booming 1960s. The business district had migrated to the south, while much of north Weirton was torn down as the plant expanded. On the left is Sterling Gasoline, and on the right are G. C. Murphy and Company and the Weirton Savings and Loan Company. (Courtesy of Krista S. Martin.)

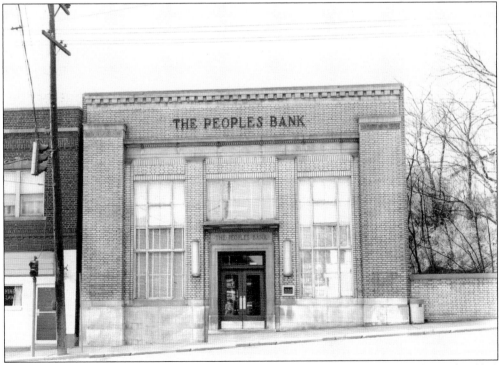

The People's Bank opened in 1923 and, in 1930, moved to this two-story building located at 3383 Main Street, where it operated until 1966. (Courtesy of Edmund DiBacco.)

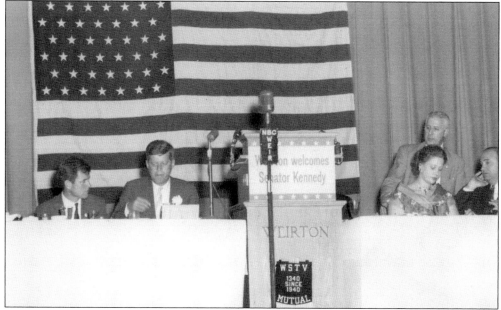

Then-senator John F. Kennedy spoke at the Milsop Community Center during his 1960 campaign for the presidency. Ted Kennedy sits to his right. His victory over Hubert Humphrey in West Virginia's primary election proved that, despite being Catholic, he could win in predominately Protestant states. Fifty-eight percent of Hancock County voted for Kennedy in the general election, including 65 percent of the Butler district, where Weirton is located. (Courtesy of Caroline Castelli Herron.)

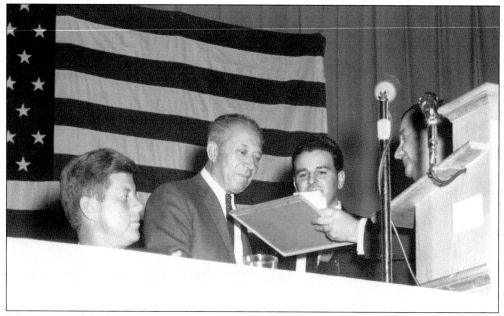

John F. Kennedy looks on as Romano "Romie" Castelli receives an award from Michael Sinicropi, president of the Italian Sons and Daughters of America, which sponsored the event. Castelli, an Italian immigrant, owned Weir-Cove Moving and Storage. Sinicropi was a campaign manager in the First Senatorial District in West Virginia for Kennedy. (Courtesy of Caroline Castelli Herron.)

Six

FROM ROCK SPRINGS TO MOUNTAINEER PARK

At the beginning of the 20th century, Rock Springs Park in Chester attracted tourists from all over the tristate region. Rock Springs had been a popular picnic site in the 19th century, and in 1897, the Chester Bridge Company, which purchased the land, built a dance pavilion, café, dining hall, shooting gallery, and bowling alley and enhanced the site's natural beauty with paths and landscaping. C. A. Smith bought Rock Springs Park in 1900 and over the next several years added a merry-go-round, casino, grandstand, and bathing and boating facilities. In 1906, Smith built the ride known as the World Famous Scenic Railway for $20,000. The park added rides over the years (the Cyclone was one of the most popular) while others were torn down. Historian Roy Cashdollar recalled the Farewell Dance at Virginia Gardens in 1974 when the buildings and equipment were auctioned off: "Hundreds came back to the site of many happy memories for them."

Now at the beginning of the 21st century, Mountaineer Race Track and Gaming Resort has become an enormously popular tourist destination. In the last 10 years, Mountaineer increased its average daily purse for races by a factor of eight, which more than tripled the number of licensed horsemen in the region; installed 3,200 slot machines; added 1,300 new jobs; and generated $25 million in revenue for Hancock County. As manufacturing has declined, tourism has become the economic focus of the county.

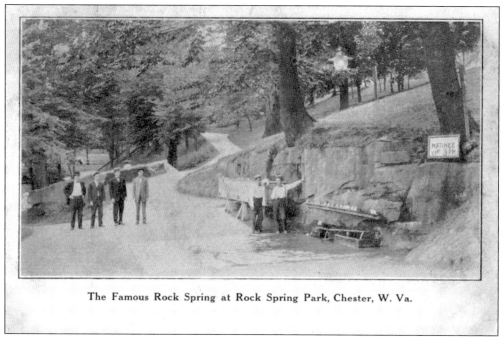

The Famous Rock Spring at Rock Spring Park, Chester, W. Va.

This postcard is of the famous Rock Springs that gave Rock Springs Park its name. (Courtesy of Krista S. Martin.)

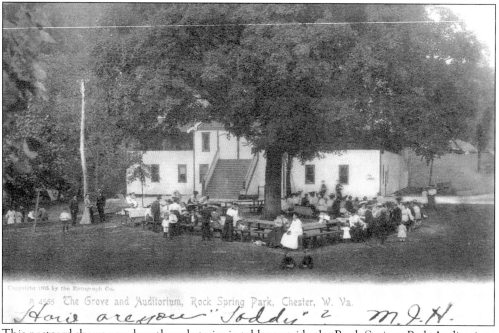

This postcard shows people gathered at picnic tables outside the Rock Springs Park Auditorium in 1903. This had been a popular picnic area since as early as the 1850s. (Courtesy of Krista S. Martin.)

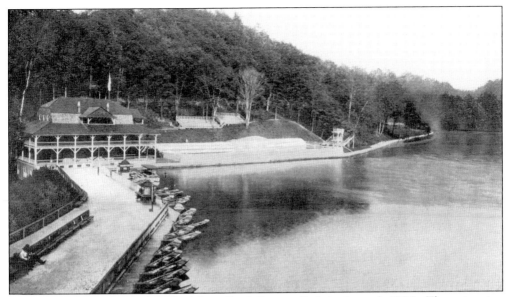

Canoes line up on the dock of the lake at Rock Springs Park in the early 1900s. The swimming pool is to the right of the Bathing Pavilion. (Courtesy of Krista S. Martin.)

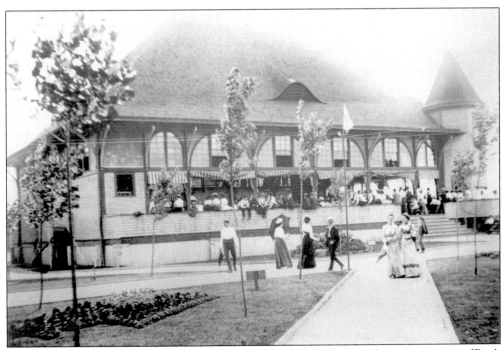

This appears to be the original Dance Hall that sat on the hill overlooking the main entrance of Rock Springs Park in 1898. It was consumed by fire in 1914. (Courtesy of the Arner Funeral Chapel.)

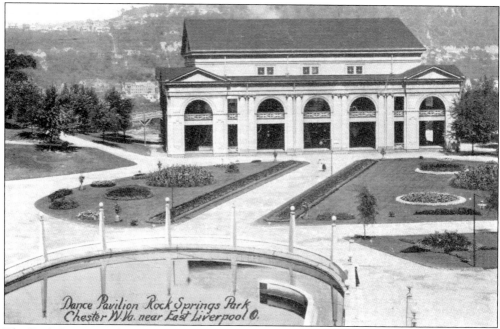

The Rock Springs Park Dance Pavilion was built to replace the original that burned down. The same building is referred to as the Casino in other postcards. (Courtesy of Krista S. Martin.)

A tragic fire at Rock Springs Park in June 1915 on the Old Mill Ride killed three children: Albert Rayner, age 12, Eva Dales, 14, and Glenna Stout, 17. (Courtesy of the Arner Funeral Chapel)

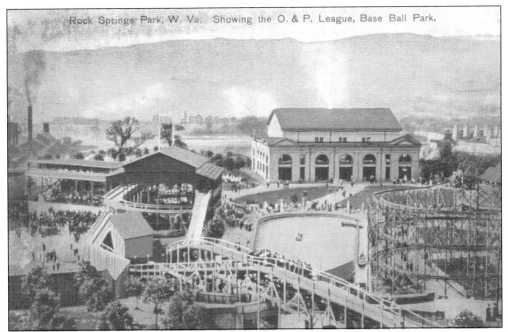

Rock Springs Park, W. Va. Showing the O. & P. League, Base Ball Park.

This image of Rock Springs Park shows the O&P League ball park on the left, where a professional baseball team owned by C. A. Smith played. The stacks of the Chester Rolling Mill are visible at the top left, while bottle kilns can be seen in the background on the right. (Courtesy of Krista S. Martin.)

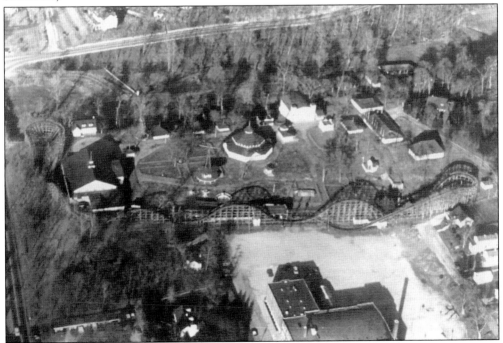

This aerial photograph of Rock Springs Park was taken c. 1970. The last day the park was open to the public was Labor Day, 1970. After the equipment was auctioned off in 1974, the park was torn down to make way for the exit ramps of the new bridge. (Courtesy of Dr. Mike West.)

Waterford Park was opened on May 19, 1951, nearly 15 years after Al Boyle announced plans to build it. Success at his race track in Charles Town, West Virginia, encouraged Boyle to expand, but the onset of World War II and a series of smaller problems after the war delayed construction. This photograph of the Waterford Inn appears to have been taken in the 1970s. (Courtesy of the Hancock County Historical Museum.)

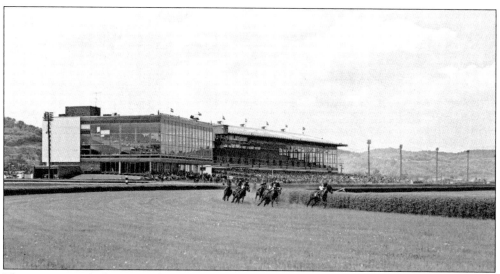

This is a postcard of a race on the grass track at Waterford Park in the 1960s. A fire on December 21, 1963, destroyed the original grandstand. The new one, pictured here, included a glass-enclosed terrace dining room. (Courtesy of the Hancock County Historical Museum.)

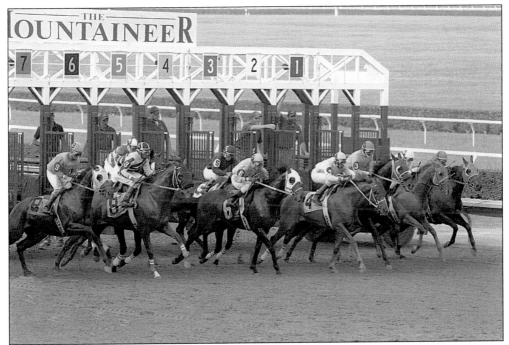

Although this photograph was taken quite recently, there is something timeless about the start of a Thoroughbred race at Mountaineer Race Track and Gaming Resort. The racetrack changed ownership first in 1987, when the name was changed to Mountaineer Park, and then again in 1992, when the company that would become MTR Gaming Group, Inc., purchased it. (Courtesy of the Mountaineer Race Track and Gaming Resort.)

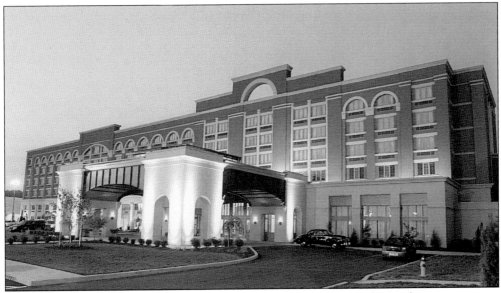

The Grande Hotel opened on May 1, 2002. This $25-million, 258-room facility features a gourmet restaurant, La Bonne Vie; spa; piano bar; and coffee shop. The hotel was part of a $60-million renovation and expansion announced in 2000. (Courtesy of the Mountaineer Race Track and Gaming Resort.)

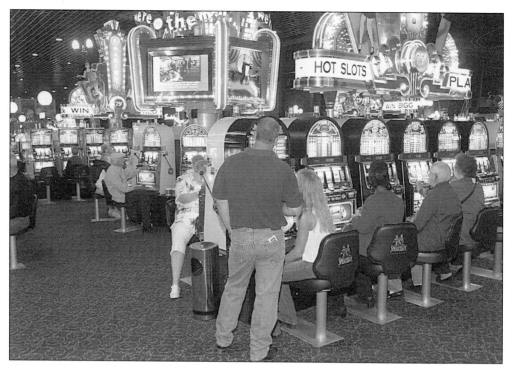

Mountaineer was first granted a license for video lottery machines in 1994. Presently they have six gaming rooms that feature over 3,200 slot machines. (Courtesy of the Mountaineer Race Track and Gaming Resort.)

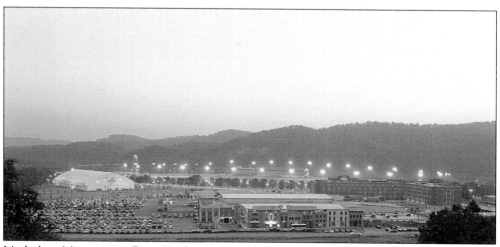

It's dusk at Mountaineer Race Track and Gaming Resort. On the far left is the Harv, a 4,000-seat arena. The Speakeasy Casino is in the center foreground. The racetrack is in the center background. The Grande Hotel is pictured on the right. (Courtesy of the Mountaineer Race Track and Gaming Resort.)

BIBLIOGRAPHY

Barnett, Bob. "Friday Night Rites: High School Football in the Northern Panhandle." *Goldenseal* 17, no. 3: 55–59.

Blaszczyk, Regina Lee. " 'Reign of the Robots': The Homer Laughlin China Company and Flexible Mass Production." *Technology and Culture* 36, no. 4: 863–911.

Cashdollar, Roy. *A History of Chester: The Gateway to the West.* 2nd ed. Boyd Press, 1985.

"Fire at Rock Springs Park." *The (New Cumberland) Independent.* June 10, 1915. Available online at www.wvculture.org.

Fones-Wolf, Elizabeth and Ken Fones-Wolf. "Cold War Americanism: Business, Pageantry, and Antiunionism in Weirton, West Virginia." *Business History Review* 77 (Spring 2003): 61–93.

Golden Jubilee: All Saints Greek Orthodox Church, Weirton, West Virginia. Weirton: All Saints Greek Orthodox Church, 1969.

Henthorne, Ruth, et al. *The History of Newell and Vicinity.* 2nd ed. Newell: 1982.

Huff, Erma. *Up High and Down Main in Pughtown, West Virginia.* New Cumberland, WV: Hancock Courier Printing Company, 1981.

Javersak, David T. *History of Weirton, West Virginia.* Virginia Beach: Donning, 1999.

Lizza, Richard. "Some Dimensions of the Immigrant Experience: Italians in Steubenville, Ohio and Weirton, West Virginia, 1900–1930." Dissertation. West Virginia University, 1984.

Mack Manufacturing Co. [Catalog]: Sewer Pipe, Paving Brick and Blocks. Philadelphia, c. 1902.

Mountaineer Race Track and Gaming Resort Media Guide, 2004–2005. Oakdale, PA: Knepper Press.

New Cumberland, West Virginia: People and Places, 150 Years, 1839–1989. New Cumberland, WV: Hancock Courier Printing Company, 1989.

Orler, Inez. *Frontiersmen ESOP.* Parsons, WV: McClain Print Company, 1984.

Stewart, Col. George, et al. *A Short History of New Cumberland, West Virginia: The Town, the People and the Background.* New Cumberland, WV: Hancock Courier Printing Company, 1976.

Truax, Louis. "The 200th Anniversary of the City of Weirton: and My Life Story as I Have Seen Weirton Grow." 1972.

Welch, Jack. *History of Hancock County, Virginia and West Virginia.* 2nd ed. Abilene, TX: WriteRight Publishing, 1992.

DISCOVER THOUSANDS OF LOCAL HISTORY BOOKS FEATURING MILLIONS OF VINTAGE IMAGES

Arcadia Publishing, the leading local history publisher in the United States, is committed to making history accessible and meaningful through publishing books that celebrate and preserve the heritage of America's people and places.

Find more books like this at
www.arcadiapublishing.com

Search for your hometown history, your old stomping grounds, and even your favorite sports team.